LOOKING FOR ASIAN AMERICA

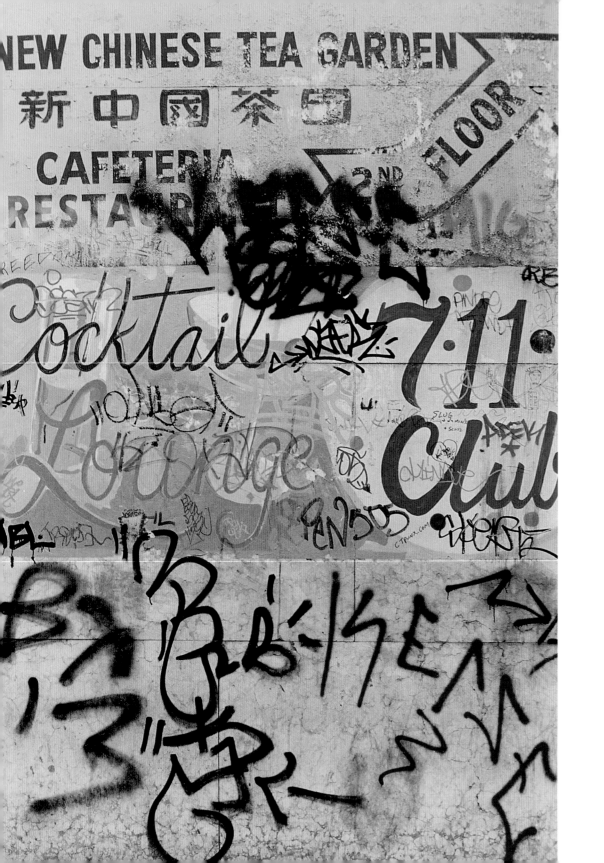

LOOKING FOR ASIAN AMERICA

AN ETHNOCENTRIC TOUR BY WING YOUNG HUIE

WING YOUNG HUIE

FOREWORD BY FRANK H. WU

ESSAY BY ANITA GONZALEZ

TRAVELOGUE BY TARA SIMPSON HUIE

University of Minnesota Press
Minneapolis • London

The University of Minnesota Press gratefully acknowledges the assistance provided for the publication of this book by the McKnight Foundation.

Published by the University of Minnesota Press
111 Third Avenue South, Suite 290
Minneapolis, MN 55401-2520
http://www.upress.umn.edu

Library of Congress Cataloging-in-Publication Data

Huie, Wing Young, 1955-
Looking for Asian America : an ethnocentric tour by Wing Young Huie / Wing Young Huie ; foreword by Frank H. Wu ; essay by Anita Gonzalez ; travelogue by Tara Simpson Huie.
 p. cm.
"The exhibition Nine Months in America: An Ethnocentric Tour by Wing Young Huie premiered at the Minnesota Museum of American Art, St. Paul, April 17-August 1, 2004. This book is an extension of the exhibition, which included more than one hundred photographs."
ISBN-13: 978-0-8166-4672-2 (pb : alk. paper)
ISBN-10: 0-8166-4672-4 (pb : alk. paper)
1. Asian Americans--Portraits--Exhibitions. 2. Huie, Wing Young, 1955---Exhibitions. I. Gonzalez, Anita. II. Wu, Frank H., 1967- III. Minnesota Museum of American Art. IV. Title.
TR681.A75H85 2007
779'.08995073--dc22

 2007012549

Printed in Italy on acid-free paper

The University of Minnesota is an equal-opportunity educator and employer.

Frontispiece: San Francisco, California

15 14 13 12 11 10 09 08 07 10 9 8 7 6 5 4 3 2 1

For my mother and my father

CONTENTS

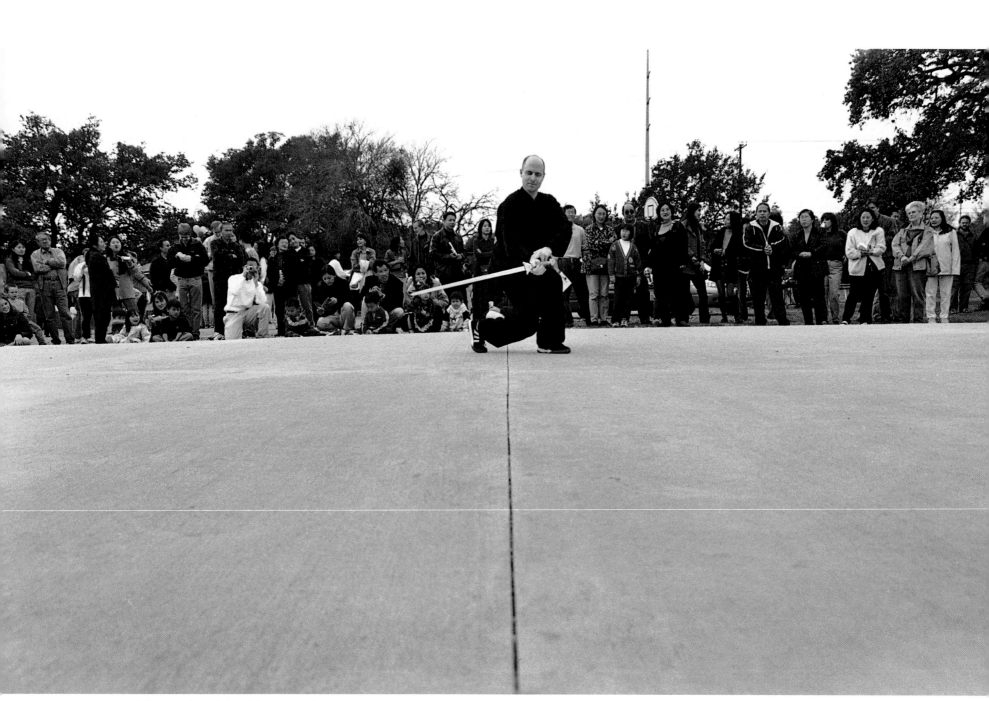

Asian American Cultural Center, Austin, Texas

FOREWORD

FRANK H. WU

Charlie Chan remains alive and well . . . but he has company now.

The pages here show real people engaged in the full range of human activity. This is no small accomplishment for the photographer or his subjects. For Asian Americans, both the newcomers and the native born, it is extraordinary to be merely ordinary. To others even if not themselves, Asian Americans appear to be contradictions of identity—a Chinese Yankee is a knockoff.

Neither Asian Asians (the cousins overseas) nor "real" Americans (the neighbors next door) seem ready to accept the authenticity of Asian American lives. They are prepared to accept a white American or a black American, and perhaps they can adjust to a Puerto Rican or Mexican American. Each of these ethnicities can claim to belong to the body politic, however awkwardly, and all of them can lay claim to a birthplace within shared borders.

Asian Americans experience, in disorienting moments, the shock of the mirror's reflection. They see they are not like everyone else around them, but somehow they embody the rise of the East and the fall of the West. Notwithstanding a family resemblance to other Asians, they boast cultural affinities to other Americans.

When they travel to an ancestral homeland as a tourist, their senses conflict. Their eyes register that everyone looks like them. Their ears hear, as soon as they try to communicate in the language that is assumed to be in their blood, that they betray themselves as foreigners or idiots (if there is any meaningful distinction between the categories). They belong only until they try to make themselves understood and then they are instantly fakers. Others are embarrassed for them for having lost their heritage, as if it could be misplaced like a childhood toy forgotten.

Returning home to where the hearth is, their self-perception and others' perceptions conflict. They forget that they cannot be part of the crowd however carefully they follow the fads. They can be invisible to others on the street, but they can become conspicuous at the wrong moment. At best they are greeted as diplomatic dignitaries from an ancient civilization and at worst they are mocked as inept social climbers. The more successful they are, the more threatening they are as the Yellow Peril.

Whoever they may wish to be and whatever they aspire to become, they share a set of stories. The Asian American condition is to lack control over one's own identity.

In the United States of America, a grand experiment of self-governance that is self-consciously exceptional, a "city upon a hill" for others to admire in the vision of self-appointed founders, the millions of people whose ancestry lies across the Pacific are "strangers from a different shore" in the title of historian Ronald Takaki's magisterial book. They do not invent themselves; they copy the majority. Their ancestors were excluded from immigrating, barred from naturalizing, and imprisoned during wartime. Asian men could not marry white women; Asian women could come as picture brides or war brides or be mistaken for the same. They were compelled to assimilate for the sake of gaining acceptance, while expected to remain ethnic enough to be exotic on cue.

"Chink," "Jap," "Gook" are the epithets used by non–Asian Americans to describe them. "Banana" is the term of derision used by other Asian Americans if they are trying too hard to be "yellow on the outside, white on the inside."

Never mind, though, what others might believe about Asian Americans. That is the least of the problems a stereotype creates for its subjects. The images of Asian Americans inform the subjects, falsely, about their own fates. Thanks to the color of skin, the texture of hair, the shape of eyes, a script becomes internalized.

Charlie Chan, the Hawaiian Chinese pulp fiction detective—played by Caucasians made up in "yellowface" reciting mock Confucian gibberish-wisdom—was the most popular star of movie serials just before World War II. Chan was a dapper dresser: he had a neatly trimmed mustache, a handsome hat, and a well-pressed white suit. He certainly seemed to be the better of those surrounding him, among them his Number One Son, a nuisance trying to impress with his hip-ster ways.

Nonetheless, Chan the elder was the fantasy of a perfect Asian. He was detached, with the barbarian hordes he represented hidden away at a home rarely glimpsed. He was always deferential in the face of his obvious superiority to other police, witnesses, and the culprit. White audiences are comforted knowing their man can be counted on not only to solve the mystery at hand but also to tolerate the casual prejudice directed against him (and, incidentally, against the rare "colored" character in the background). His fans were much more likely to interact with him as a fictional figure than they were to befriend an actual Asian American. He becomes a model of behavior for all Asian Americans.

In contrast, we see the people in these portraits by Wing Young Huie as who they are. We encounter them as they present themselves. The viewer might infer much about these strangers caught on the printed page: no doubt some are smart, some less so; some hardworking, some lazy; some proud, some ashamed; many successful, others not; happy, lonely, creative, and so on.

It is reasonable to guess that they are individuals who belong to many communities, whether arbitrarily or deliberately. Despite being told "you all look the same," Asian Americans are as different from each other as they might differ as

a group from other Americans. It matters whether you grow up as the only Asian American around or if you grow up among enough others to form a critical mass. Stereotypes contain stereotypes; they collapse into caricatures. There is a separation between and within Asian Americans, in members of the same clan—the one looking for roots in Asia, the other trying to plant them in America, both desperate.

Perhaps they speak with a Texas twang, a Chinese accent, or both. While we will never know any of these people beyond this moment in which they were photographed, each one undoubtedly has already changed much since then. Their identity is dynamic rather than static. They acquire more of a twang and end up with less of an accent through dedicated study, because they are convinced correct pronunciation enhances their job prospects; or vice versa, when they return home for a holiday with family and resume a familiar role.

Frank Wu in his driveway, Washington, DC

It is fair to infer from the circumstances that all Asian Americans have been made the quintessential promise of the "melting pot." The bargain is as follows: forsake your grandparents and parents and become our friends; if you do this and only this, we will embrace you as an equal. It contains a threat, barely concealed: continue on your own and we will reject you as a traitor, because we and those before us confronted the same dilemma and conformed to the popular choice.

The irony (in the true meaning of the word—a dramatic revelation learned too late for the protagonist but evident all along to others) is that the contract must perforce be breached. It is the Asian American with the Anglophone name, eyelid surgery, and permed hair, the poser with the bizarre fantasy of becoming Sinatra or Monroe, who is shunned as freakish. The Asian American who is still recognizable as the geek or the geisha presents no more of a challenge to normality than the ubiquitous Chinese restaurant or the sushi at supermarkets.

So it is that the American Dream is embodied by this project. This book is possible only because of that American Dream. America is defined by movement— literally, every step of the way. The cliché is belabored before it is uttered: to be an American is to come from elsewhere and to be afflicted by restlessness forever after. It is to be part of the lines embarking at Ellis Island in the East or Angel Island in the West, the wagon train across the plains, the trail of tears, white flight, suburban

sprawl, the exodus from the dust bowl portrayed by John Steinbeck in *The Grapes of Wrath,* the Middle Passage of slavery, the Underground Railroad to freedom in the North, the Great Migration of African Americans toward economic opportunity, the marches for civil rights, the smuggler's human cargo packed into vans or container-ships, and the Beat Generation on the road.

Asian Americans were an integral part of manifest destiny, but they were not integrated into the picture. Although more than ten thousand Chinese laborers laid the tracks for the transcontinental railroad in a competition against Irish crews, they were not invited to the ceremony when the robber barons drove the Golden Spike. More than a century passed before Promontory, Utah, witnessed an Asian American reenactment of the scene.

The American Dream is more mirage than memory. For almost all of us, our days are ethnocentric. As we lapse into sedentary routines, inertia produces insularity. We live among "our people" in the suburbs, and we define ourselves thus.

By comparison, Wing Young Huie and Tara Simpson Huie could not help but set off on "an ethnocentric tour." They are artists, which is clear from their compelling project. It is rooted in a sense of who they are, but it is expansive. There is no superiority to either of them; instead, there is an openness that comes from them together. An Asian American man and a European American woman who journey across the continent stand out. They should speak out.

The descendants of Charlie Chan are the new Americans . . . and the nation is theirs.

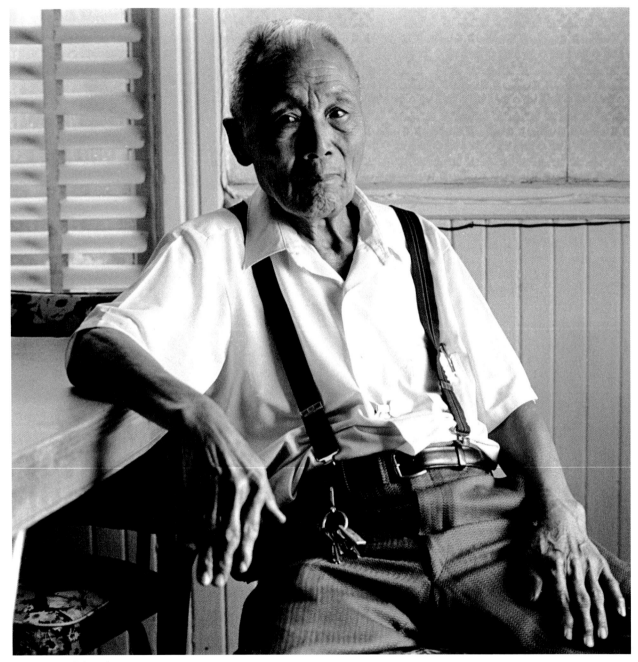

Joe Huie at eighty-three years, 1976

PREFACE

I am the youngest of six children and the only one in my family not born in Guangdong, China. For most of my life I've looked at my own Chineseness through a white, middle-class prism. Growing up in Duluth, Minnesota, made this easy—after all, I was weaned on Snoopy, Mary Tyler Moore, and Johnny Quest. Mom made me pray to Buddha every New Year, but it was Jesus Christ Superstar who became my cultural touchstone. The result was that sometimes my own parents seemed exotic and even foreign to me.

They also were my first photographic subjects. I was twenty and living at home, experimenting with my new Minolta, when I made the first exposures of my dad in the kitchen. It was strange and exhilarating to look at someone so familiar so intently—and see something new.

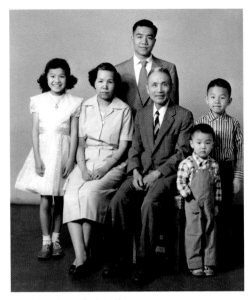

Huie family, Duluth, Minnesota, 1959

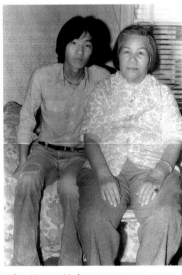

Wing Young Huie at age twenty-one
with Lee Ngook Huie, 1976

Twenty-five years later I embarked on a nine-month, cross-country odyssey, determined to see the exotic as familiar and vice versa, collecting the clues that would inform my evolving, hyphenated point of view. In August 2001, one month before fated 9/11, Tara and I loaded up our green Volkswagen Bug, deciding what was essential for a nine-month road trip. We were newlyweds married less than a year, thrilled and overwhelmed about the endless possibilities ahead.

I had received fellowships from the St. Paul Companies and the Jerome Foundation that would allow me to "explore the changing cultural landscape." For the past twelve years I had been photographing the dizzying socioeconomic, ethnic, and cultural realities that were defining a new Minnesota, one that didn't resemble the Duluth of my youth. We were the only Asian family in the neighborhood and I was always the only Asian kid in class—until the tenth grade, when another kid showed up, whom I avoided.

Understanding the causes for that curious avoidance has been a gradual unfolding process, and one of the reasons for taking this trip. I had other questions as well. Would I have turned out differently if I had grown up in Chinatown, for instance, or in the Deep South? How would my "Chineseness" have been affected? Are there Chinese with southern drawls? Would I speak Chinese more fluently? Would I have chosen to be an artist or ended up working in a Chinese restaurant? Would I have married someone Chinese?

I remember how my mother would try to coax me to marry someone Chinese. I would tease her by saying I was going to marry a "lo fan" (white person) instead, because I never met any Chinese girls, but if she gave me enough money I might reconsider. A thousand dollars, she would reply with a laugh, and I would shake my head to say it wasn't enough.

I'm not sure how serious she was, but when I was in high school I brought home a girl who was white. It upset my mother enough that I decided never to do it again, which became an issue for future girlfriends. Mom died nearly ten years ago, and I am now left with a discomforting mixture of sadness and relief that she never met my *lo fan* wife.

With these thoughts in mind Tara and I headed west out of Duluth, on blue highway 2, with little itinerary and lots of questions: an "ethnocentric" community of two trying to connect to a larger whole. A partial list of what we saw: lonely motel TV sets featuring a white guy with a Fu Manchu playing a Mandarin; a wax Whoopi in Vegas; Buddhist temples and bubble tea bars; a winking Indian billboard on top of a business supply store; a Vietnamese Elvis; migrant-working Mennonites; a demolition derby; meditating Falun Gong protesters; Miss Congeniality on her cell; a Chinese theme park in Orlando; ABCs; FOBs; the only full-blooded Chinese in Lahaina, Maui; and a self-described "redneck Chinese restaurant owner" near the Okefenokee Swamp. The photographic facts gathered during those nine months reflect an ethnocentric point of view that is below the prevailing cultural radar but is as American as Buddha bars, Bruce Lee dolls, and chop suey.

The trip ended in May 2002 and two years later, after sorting through seven thousand photographs and thirty hours of digital video footage, *Nine Months in America: An Ethnocentric Tour by Wing Young Huie* premiered at the Minnesota Museum of American Art in St. Paul, Minnesota. The exhibition included 105 photographs, a video of two and one-half hours that played on three screens, nine "stories" written by me, and a journal by Tara.

Originally I wanted Tara's name in the exhibition title, but she adamantly refused. This project was, however, collaborative on many levels. Together we met almost all of the people I photographed and we interacted with them as a couple. Sometimes she would make the approach. I remember an Asian man in a cowboy hat and business suit seated at a sushi bar in El Paso whom Tara insisted I photograph. The digital video we produced was an equal partnership: she held the camera and we both asked the questions.

The journal, though, was all Tara. Her observations of our interactions with the people we met catalog the serendipity and humor of life on the road, as revealed by a few of her headings: Mennonites in the Parking Lot; Molokai Mo Bettah; Connie Francis, Move Over; and Honey, Don't Back Over the Prostitute. They are written

from the viewpoint of a white woman raised in middle-class, suburban Minnesota, whose knowledge of Chinese culture, language, and medicine far surpasses mine. She didn't grow up needing to think about ethnocentric implications, but she constantly bumped into them because of the focus of the trip and because she was married to me.

Each of the fifteen stories I wrote for this book refers to a specific photograph. The collective stories are as much about me as they are about the circumstances surrounding the photographs, and their order does not reflect our linear, counterclockwise journey around the country.

It has taken me four years to digest all the material and experiences accumulated during those nine months. I'm digesting it still. Before the trip the word "ethnocentric" rarely passed my lips. For much of my life I was decidedly in avoidance of my personal ethnic personae. Now I believe that ethnocentrism affects everything, societal and personal—the whole enchilada, as they say. Here, then, is my ethnocentric view, in four parts:

1 I was born and raised in Lake Wobegon, assuming not only that I was like everyone else but also that I looked like everyone else. After all, you don't grow up with a mirror in front of you: you become what you see. As I spent more time away from home, mass culture became my mirror.

From time to time, though, that bubble was burst. Like when my junior high band teacher announced to my fellow band members that they should look to me as a role model because of my industrious Chinese work ethic. Or when that cute girl who worked at Bridgeman's said she couldn't go out with me because her dad had fought in World War II.

2 Not long after I graduated from college, a Jewish friend said something that stunned me. We were sitting in a bar where I was a regular and at the end of the evening, after I had introduced her to the other regulars, she turned to me and asked, "Doesn't that annoy you? How your friends make all these dumb references to you

being Chinese?" I had no idea what she was talking about. I was upset and refused to acknowledge what was so apparent to her.

3 I was living in a raw warehouse space during my early thirties, making my way as an artist. My next door neighbor, a Japanese American, invited me to a meeting for a fledgling organization that promoted Asian artists. About twenty people were there, all Asian. It was the first time in my life that I had walked into a room full of Asians without being related to any of them. I didn't know why at the time, but it made me uncomfortable. All they talked about were "Asian issues." I later joked to a friend that it was like going to an AA meeting.

4 In this age of spin, points of view are what matters, especially ethnocentric ones. They shape personal attitudes and worldviews. The constant battle for who determines the interpretation of facts is the modern dilemma. Objectivity and veracity have become meaningless.

Public opinion on Rodney King, O.J., and now Chai Vang (the Hmong immigrant from Minnesota convicted of killing six white hunters in Wisconsin in 2004) shows us that guilt or innocence is decided by our ethnocentric histories rather than the "facts" of a trial. Even science is divided by the same ethnocentric subjectivism when it comes to issues such as the origin of our species.

Yet many ethnocentric points of view are construed as fact. Lake Wobegon, for example, is clearly an ethnocentric creation, yet many believe that Minnesota is indeed Lake Wobegon. I'm a big fan of the fictional radio-show town, but the fact is that I'm a native Minnesotan and I can't live in Lake Wobegon. Hundreds of thousands of hyphenated folks like me simply do not exist in Lake Wobegon, but we do live, albeit tentatively, in a place called Minnesota.

Wailuku, Hawaii

AUTOBIOGRAPHY AND ETHNO-CENTRICITY

ANITA GONZALEZ

In 2001, the undeveloped but general idea for the exhibition *Nine Months in America: An Ethnocentric Tour by Wing Young Huie* came about when I learned that Wing and his wife, Tara Simpson Huie, were going to travel around the United States for an extended period.[1] I was familiar with Wing's previous exhibitions *Frogtown, Lake Street USA,* and *Wing Young Huie/Schalemar Flying Horse,* and I was especially interested in how he worked with communities to integrate their perspectives and voices. These earlier projects focused on specific and local communities with imaginable boundaries. Wing spent considerable time in each of these communities and installed the completed work in these neighborhoods. How would he photograph and co-create the multiple communities he and Tara would

briefly encounter during the better part of a year, traveling throughout the entire country? What would be the "subject" of this new project?

At the start of their trip, Wing and Tara weren't sure what the outcome of the journey would be or even if there would be a resulting body of work for an exhibition. The trip was intended as a time for exploration and collaboration without the pressure to return with a "product." Wing mentioned an initial idea to photograph Chinese restaurants throughout the United States because, as he put it, "there are Chinese restaurants everywhere" so by extension there are Chinese everywhere. But he didn't want to be limited to one idea or set of parameters. In previous conversations we had talked about how his position as an artist of color informed his relationships with the people he photographed, who were usually from communities of color. I wondered how his Chinese American identity would affect his experiences traveling around the United States. Given the nature of majority–minority relations in this country and the prevalent idea that "American" citizens are White, middle class, and Christian, what would it be like for Wing and Tara, a mixed-race couple, to photograph a cross section of the United States that encompassed the spectrum from rural areas to cosmopolitan cities, as well as the diverse regional histories comprising the United States?

As the exhibition came together, I was interested in the autobiographical components of the photographs, as this was new terrain for Wing as an artist. The relationship between an artwork and the artist is multiple and varied. Many artists of color in the United States must engage with a tension that "majority" artists typically can sidestep. Artists of color are called on by both majority and minority viewers to somehow "account for" their identity in their artwork. The privilege of saying the artwork isn't about me, it's about an idea I have is not so easily accorded to artists of color as it is to White artists. While Wing's previous work included diverse perspectives from the communities he worked with, in *Nine Months in America* he directly and intentionally addressed the questions "what is my perspective as Wing Young Huie, and how do my identity and my experiences inform what I see?" I found it very significant that he chose to ask these questions rather than be positioned to deflect the unstated assumptions of the viewers of his photography.

The title of the exhibition attempted to capture this autobiographical and culturally specific dynamic, yet ironically the press seemed to get it wrong. The press and others often dropped the last phrase of the title, "by Wing Young Huie," and instead referred to *Nine Months in America: An Ethnocentric Tour.* This annoyed and bemused me because the point of the exhibition, the thesis, was that it was an ethnocentric tour *by Wing Young Huie*. It's not possible to be ethnocentric without identifying which culture is being placed in the center and by whom. But then that was the point as well. The concept of ethnocentricity typically is an ideological act of power to displace and marginalize those without power. In modern times, ethnocentricity is an extension of the colonial project. To accuse someone or something of being ethnocentric is usually to accuse that person or entity of systemically privileging their ethnic culture, political system, and position of power. This privileging includes the unstated assumption that things are as they should be—for example, that it's natural that the mass media portrays the United States as a primarily White, middle-class, and Christian culture. In titling the exhibition as he did, Wing chose to deliberately question and challenge the ways an unstated ethnocentricity pervades the vastness of the United States and to simultaneously privilege his own ethnocentric view.

In simplest terms, the photographs in this book are portraits and landscapes, although they are by no means traditional. The photograph of the girl in *Death Valley, California* is both a portrait and a landscape as well as a beautiful composition of texture, proportion, color, and mood. The girl is phenotypically Asian and appears to be a tourist posing in front of a national monument: this is all the viewer can know. Whether one imagines her to be Asian American (is she a Chinese American whose family has lived in California for generations?) or from the Chinese mainland or elsewhere depends on the experiences and assumptions of the viewer.

During the run of the exhibition, one visitor asked, "Why are there images of non-Asian things?" While there are many images that "evoke Asian" (whatever that is), I imagine there was some confusion for this visitor—is this an ethnocentric tour or isn't it? If it's ethnocentric, why are you mixing up the ethnicities? Why *Party on the Prairie, outside Beulah, North Dakota* and *Foghat concert, outside Beulah, North Dakota* with all those White rockers and the giant White penis? Exactly, I thought. The problem was that this visitor presumed to know what the perspective of the artist should be and, therefore, what his subject matter could be. It was a question of belonging, and the non-Asian images didn't belong in an "Asian exhibition."

Of course, this was an ideal instance of how *Nine Months in America* challenged viewers in different ways. The exhibition asked the questions "who gets to be an American, and how is that defined?" Wing and Tara began traveling in August 2001. Many of the photographs and certainly the videos reflect a post–9/11 sensibility, an assertion that people of color, new immigrants, and others outside the imagined boundaries of American cultural citizenship are indeed Americans. *Miss Congeniality, Chinatown, San Francisco, California* evokes the

tradition of Miss America beauty pageants with her tiara, sash, youthful beauty, and poise as she walks down the street with a very large U.S. flag in the background. She also juxtaposes expectations of who can represent the ideals of American womanhood. Could Miss America really be Chinese American? Andrea Louie writes that Chinese Americans have been "excluded from U.S. cultural citizenship on the basis of their Chineseness at the same time that they continue to be both voluntarily and involuntarily associated with China."[2] Asian Americans and other people of color in the United States know this experience from the question "where are you really from?"—as if one couldn't look "so ethnic" and be American.

The landscapes in Wing's photographs, like his portraits, are not traditional views with foreclosed meaning but rather are open to multiple interpretations. The U.S. cultural landscape as viewed by Wing is filled with memorials, billboards, and people hanging around. Images of memorials such as those in *Cemetery, Kauai, Hawaii* and *Guadalupe, Arizona* suggest the prayers not spoken in English that emanate from a diversity of American communities. The billboard between El Paso and Juárez, which is situated over the barbed wire fence with its greeting "Entre Amigos," highlights the disconnection between U.S. immigration rhetoric and practice. Those teenage boys hanging around in *Hmong Lo Street, Hickory, North Carolina* are practically living in Mayberry R.F.D.: what is life like for them? These cultural landscapes raise questions and provoke us, the viewers, to look more closely at the American landscape and its peoples. Ultimately, in presenting his ethnocentric viewpoint in this collection of photographs (or "collection of perspectives," as he has said), Wing prompts us to consider the limitations of our own frames of reference.

I have a special regard for the closing photograph in this book, *Diamond Head Crater, Waikiki, Hawaii,* because it

was the first photograph hung during the installation of the exhibit. The expanse of the sky was echoed in the large scale of the print (56 x 68 inches); although the print was black and white, you could feel the sky and sun. The giddy mood of the "tourists" enjoying their snapshots is slightly tense because they appear as if they could fall out of that sky or, alternately, as if they live in that sky. For me, this image foregrounds Wing's ethnocentric view, which is both complex, inviting a closer and slower look at his photographs, and elegant, reminding us of the beauty and dignity in our everyday lives.

Notes

1. The exhibition *Nine Months in America: An Ethnocentric Tour by Wing Young Huie* premiered at the Minnesota Museum of American Art, St. Paul, April 17–August 1, 2004. This book is an extension of the exhibition, which included more than one hundred photographs and videotaped interviews with many of the people Wing photographed. I was the cocurator of the exhibition.

2. Andrea Louie, *Chineseness across Borders: Renegotiating Chinese Identities in China and the United States* (Durham and London: Duke University Press, 2004), 22.

LOOKING FOR ASIAN AMERICA

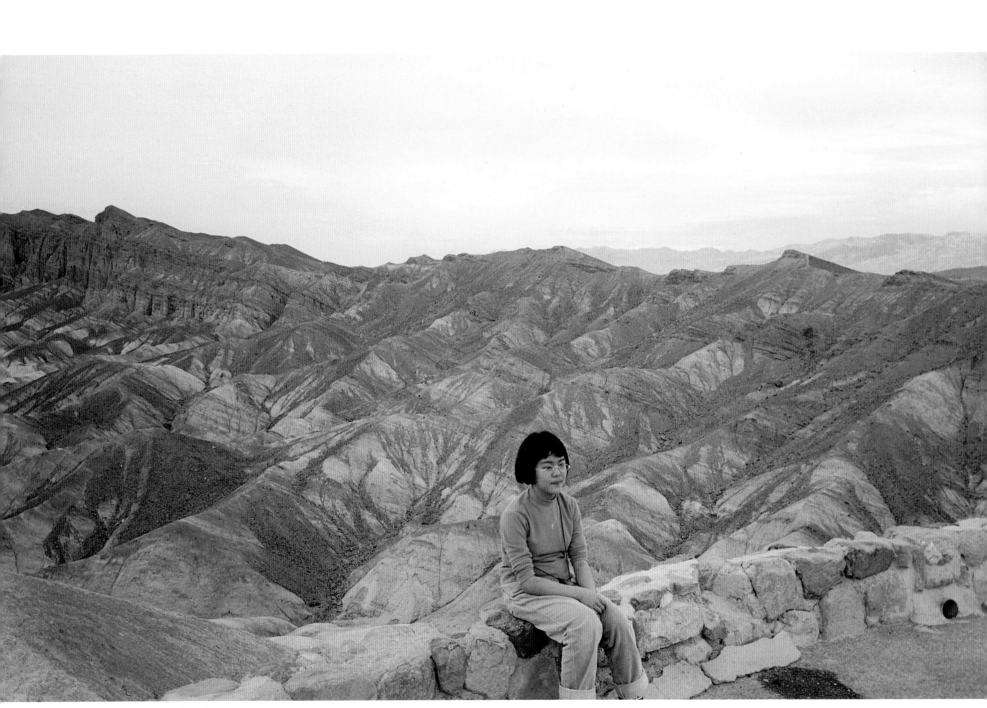

Death Valley, California

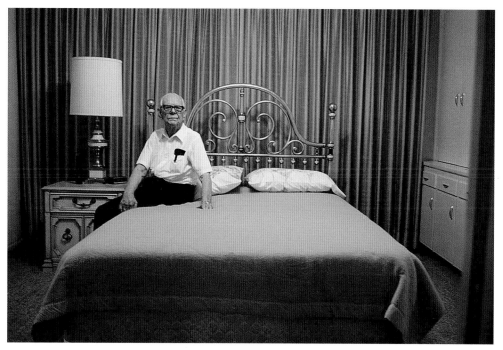

Clyde, Phoenix, Arizona (in memory)

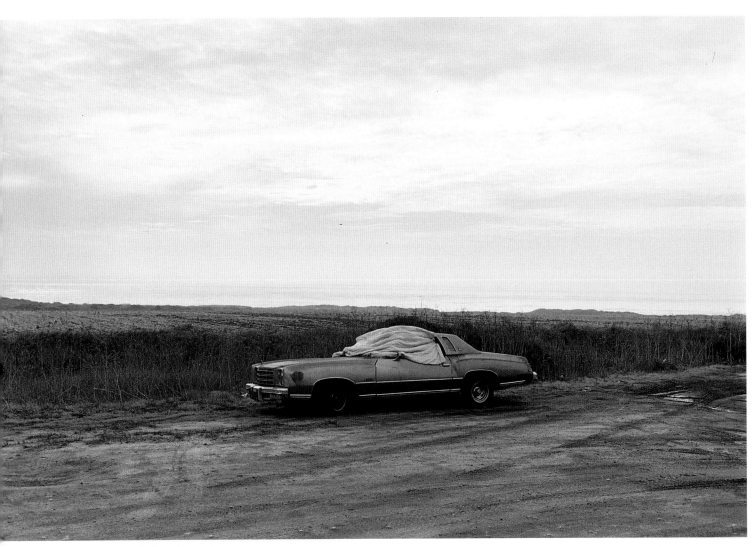

California coast

Highway 2, North Dakota

My mother never learned to speak English. For almost half a century she lived in a small brick house in Duluth and seldom ventured past the back porch that overlooked Lake Superior. I don't believe she was agoraphobic and, as far as I could tell, she was very content. She had no desire to return to China although she wrote constantly to relatives there. I don't know why Mom didn't learn English. It never occurred to me to ask. I guess normalizing your family's behavior, no matter how out of the norm it seems, is, well, normal.

One of the benefits of this trip was that it gave me the chance to ask things I didn't ask growing up. We were in Vancouver, British Columbia, at Ming Wo Cookware in Chinatown. The Chinese are now the largest ethnic minority in that region, and the family who owned the store was one of the first families to emigrate there. They arrived in 1949, one year before my mom came to Duluth. The grandmother in the family and my mom were both the same age when they emigrated—and she also never learned to speak English.

It was a familiar awkward feeling trying to talk to her in Chinese. The only person I ever really spoke Chinese with was my mom, and as I grew older and spent less and less time at home, my Chinese regressed to the point where my conversations with her became very limited. I always felt guilty about that and I carry that regret with me still.

MING WO COOKWARE

The daughter who ran the business acted as interpreter and told us that when her mom first arrived she wanted to go back. The living conditions were much better in China, and the food and surroundings in Vancouver made her homesick. When I asked why she had never learned English she replied in a laughing, agitated voice, just like my mom did when I asked her something stupid.

She raised four children and worked. When did she have the time to learn English? Going to school wasn't an option. She was ninety years old, she said, and quite content with the way she was.

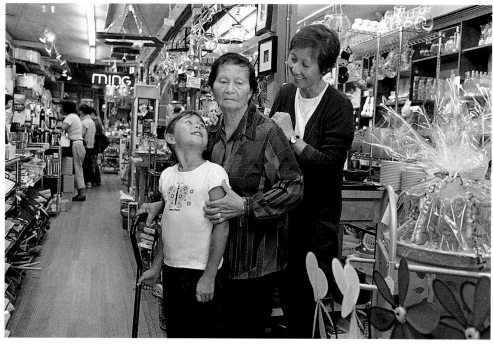

Ming Wo Cookware, Vancouver, British Columbia

Hickory, North Carolina

Shop owner, Chinatown, Vancouver, British Columbia

Ichiro Suzuki souvenir mugs, Seattle, Washington

French Quarter, New Orleans, Louisiana

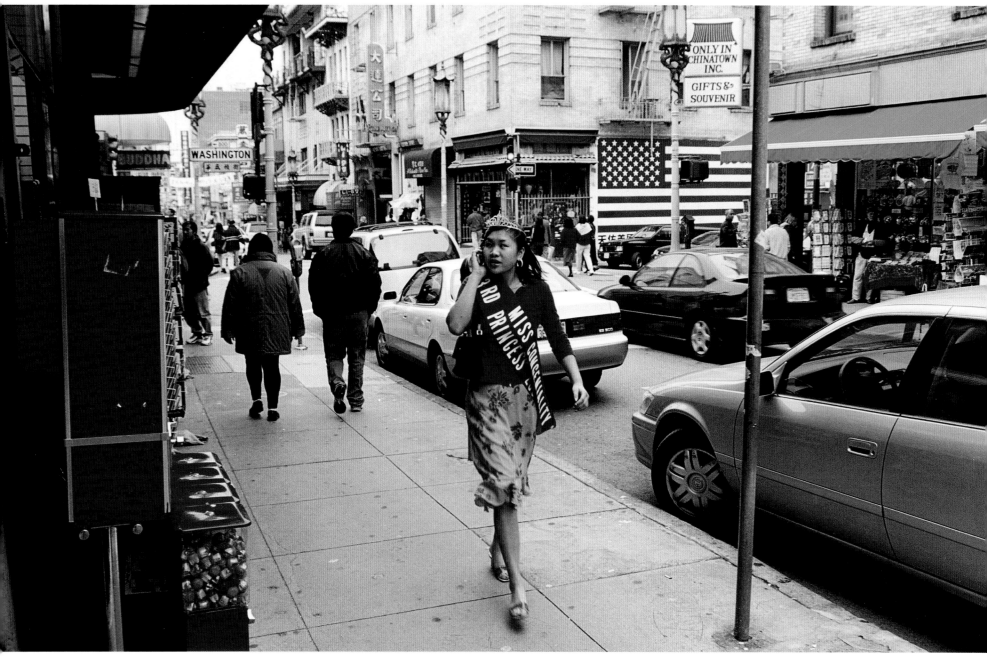

Miss Congeniality, Chinatown, San Francisco, California

Las Vegas, Nevada

Richmond, British Columbia

"Welcome to Locke" said the sign in English and Chinese. We were in the Sacramento Delta, excited to see the "only town in the United States built by Chinese for the Chinese," according to its web site. It was founded in 1915 when a group of Chinese immigrant farmworkers approached landowner George Locke to lease part of his orchard to build homes. At that time state law forbade immigrant Chinese to own land.

By the 1930s Locke flourished to a population of six hundred Chinese, with a half-dozen markets, a dry goods store, five whorehouses (all staffed by white women), an opera, two slaughterhouses, a school, and a post office. But after World War II young people moved away and the population began to dwindle. Only twelve Chinese residents remain.

Now a community of Mexican pear workers lives in the homes. A wealthy Hong Kong businessman bought the town fifteen years ago, and Mexicans ironically are in the same position as the Chinese at the beginning of the twentieth century: unable to buy property where they live and work.

We visited Locke on a Sunday, and its Main Street looked deserted and surreal, like an abandoned western movie set. There was a historical center, several shops specializing in Chinese gifts and collectibles, a repair shop, a grocery, and a Chinese restaurant—all closed. Only Al the Wop's, a saloon on Main Street, was open.

Inside Al's, someone suggested we talk to Mr. Ping Lee, the unofficial mayor of Locke who knew everything and everybody. From a pay phone we reached him and five minutes later he eagerly met us. He had grown up in Locke and lived most of his life here. He retired twelve years ago but still goes daily to The Big Store, a large grocery he owned and recently sold to a Latino family who had worked for him many years.

Ping was slight and energetic, with a commanding voice. I was shocked when he said he was eighty-four. He reminded me of my dad: self-made, proud, sure, and shrewd, with few moral dilemmas. Ping was born in America but his thinking was all Chinese. When Tara and I interviewed him he told us about one of his sons who grew up wanting to be white, married a white woman, divorced, married another white woman, and divorced again. When he said the word "white," as he looked into the video camera my white wife was holding, his assured voice faltered, but only for a moment. He then said that his son was coming around now, wanting to be like his brother, who had done the right thing and married a Chinese woman.

LOCKE

Ping Lee, Locke, California

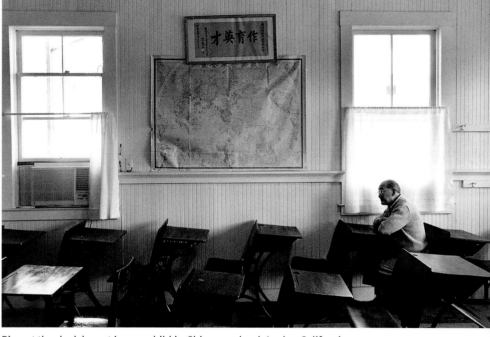

Ping at the desk he sat in as a child in Chinese school, Locke, California

Los Angeles, California

Martial artist, Seattle, Washington

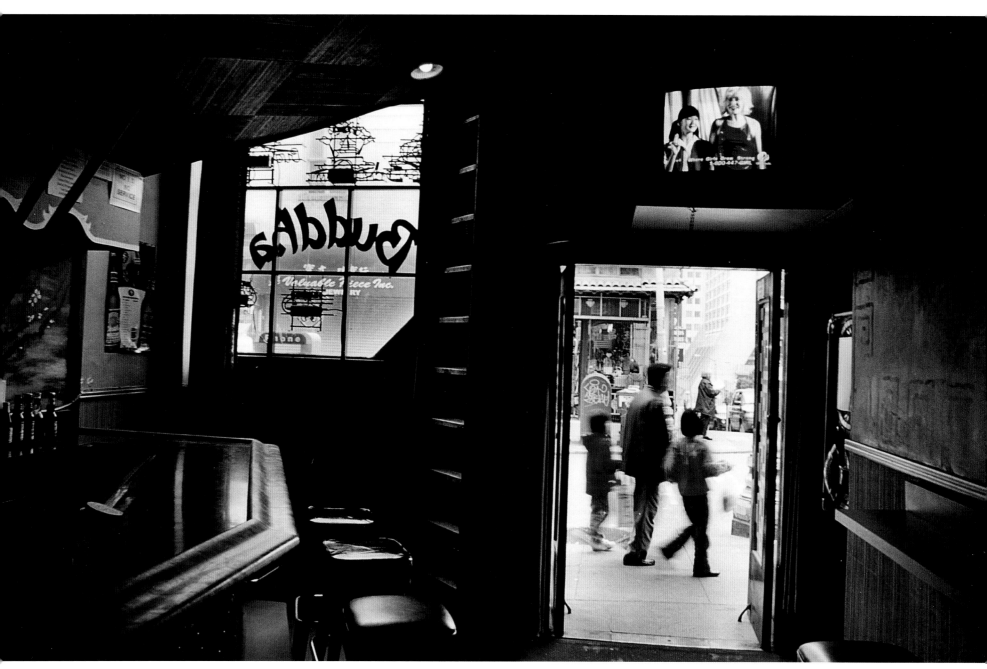

Buddha Bar, Chinatown, San Francisco, California

Ginseng farm, Marathon County, Wisconsin

Subway station, San Francisco, California

We were at the Livingston Depot Center, a museum about the Northern Pacific Railroad, looking for information on Chinese railroad workers. There wasn't much, just one photograph. The person in charge suggested that we talk to Elmer and Larkin, a local married couple, if we wanted to know about the Chinese in the area. We called them and they said they'd meet us at the café next to the museum.

Elmer, who was born and raised in Los Angeles, moved to Montana more than twenty years ago to work for the railroad because he wanted to "honor the Chinese who came before him." A century ago ten percent of Montana's population was Chinese, mostly men who were miners or railroad workers. Elmer is now the only Chinese railroad worker in the county. His wife, Larkin, an award-winning reporter for the local newspaper, the *Park County Weekly,* has written extensively about the Chinese diaspora in Montana.

After introductions we chatted for a bit and then, with their consent, turned on our Sony MiniDV. For the next several hours Elmer did most of the talking, pouring out stories about what it was like being Asian in rural Montana. He was direct, funny, and at times emotional as he eagerly released what had been built up

ELMER AND LARKIN over many years.

At one point I stepped back to take in the piled parallels and incongruities of it all. Here we were, two Chinamen—total strangers an hour ago—conspicuously huddled in a corner booth surrounded by cowboys, sharing ethnocentric stories and biracial symmetry, our communal historical significance whitewashed by the museum next door.

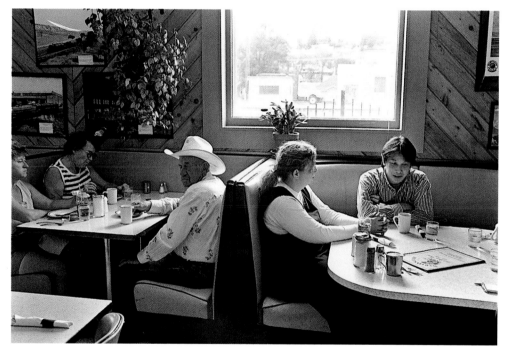

Elmer and Larkin, Livingston, Montana

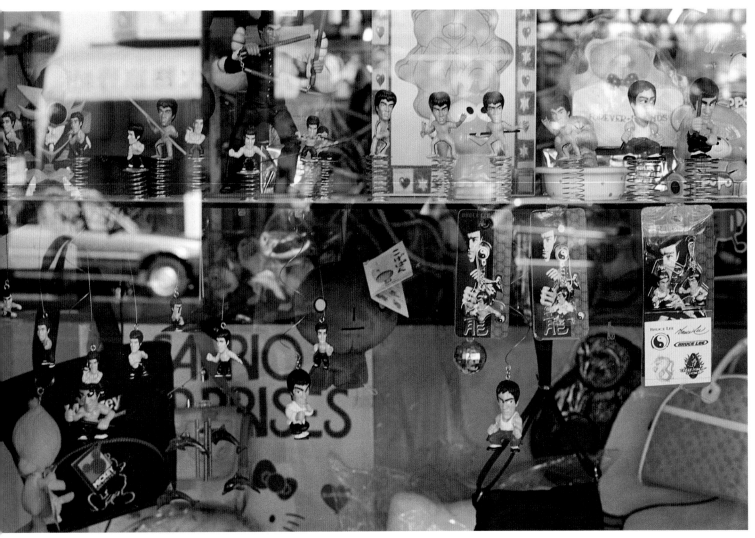

Bruce Lee kitsch, Chinatown, Vancouver, British Columbia

Beauty shop, Wenatchee, Washington

Cemetery, Kauai, Hawaii

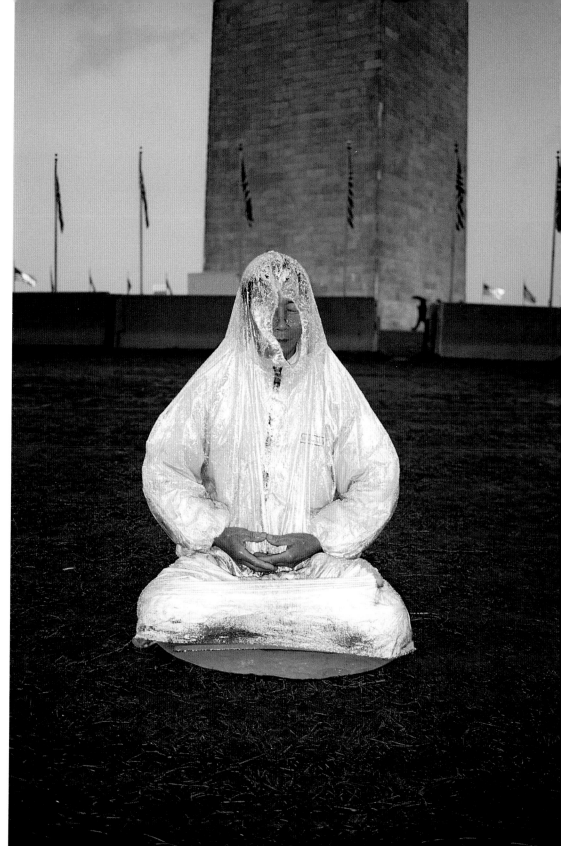

Falun Gong protester, Washington, DC

We were in a Starbucks next to the Great Mall in Silicon Valley. Sitting at the next table was a young Asian couple, flirting and teasing each other like newlyweds. I debated a while about whether to approach them or enjoy the rest of my coffee. Then they left. I ran out the door and spent the next two hours and the following day photographing them. A month later we met them in San Francisco for dinner.

Chihiro is Japanese, born in New York City but raised in Japan. Stephen, her Chinese boyfriend, is a native Californian. He grew up in an affluent white suburb where he felt that he stuck out, but in a good way. Later at Berkeley the dominant, international Chinese student population made him feel like he wasn't Chinese enough.

When I started photographing, Stephen told Chihiro to make her "Japanese face." She explained that when she was a little girl she would prepare for picture day at school by practicing in a mirror. Her mom told her that all girls are supposed to look downward, have big eyes, tuck in their chin, and make their mouth small. She said she doesn't do that anymore, but Stephen jokes that she makes that face every time a camera is pointed at her.

STEPHEN AND CHIHIRO

Chihiro, Milpitas, California

Bubble tea shop, Seattle, Washington

Cocktail lounge, Seattle, Washington

China Hardware, Little Havana, Miami, Florida

Asian American Cultural Center, Austin, Texas

Chinatown, Vancouver, British Columbia

Marrero, Louisiana

Buddhist temple, Richmond, British Columbia

Asian mall, Milpitas, California

New Year's Eve, Las Vegas, Nevada

Mardi Gras parade, New Orleans, Louisiana

According to the 2000 U.S. census, the least diverse area in the United States was Slope County, North Dakota. The *New York Times* stated that of its 754 residents only three were nonwhite. With that article in my pocket, we drove toward Slope in search of those three people. We stopped in one of its two towns, tiny Amidon, which was a collection of several buildings. The only place open was an antique shop, which we entered.

I was unsure how to broach the subject with the owner, a middle-aged man, when Tara noticed an old mah-jongg set amid the bric-a-brac. "Is that set from around here?" I asked. "I mean, are there any Chinese families nearby?" He stared at me for what seemed a long moment as he considered the question. "No Chinese here and no others either," he said. "The paper said that there were three non-Caucasian folks, but none of us know where they are."

SLOPE COUNTY

Migrant workers, Oasis Motel, North Dakota

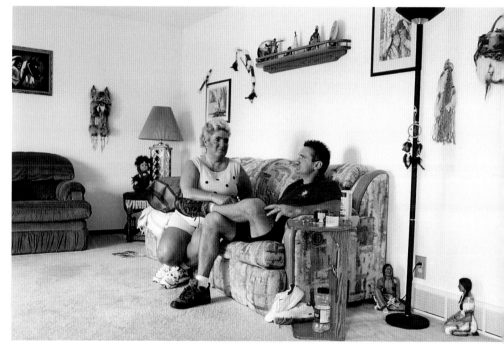

Beulah, North Dakota

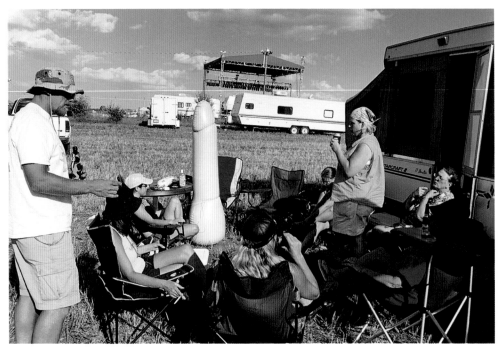

Party on the Prairie, outside Beulah, North Dakota

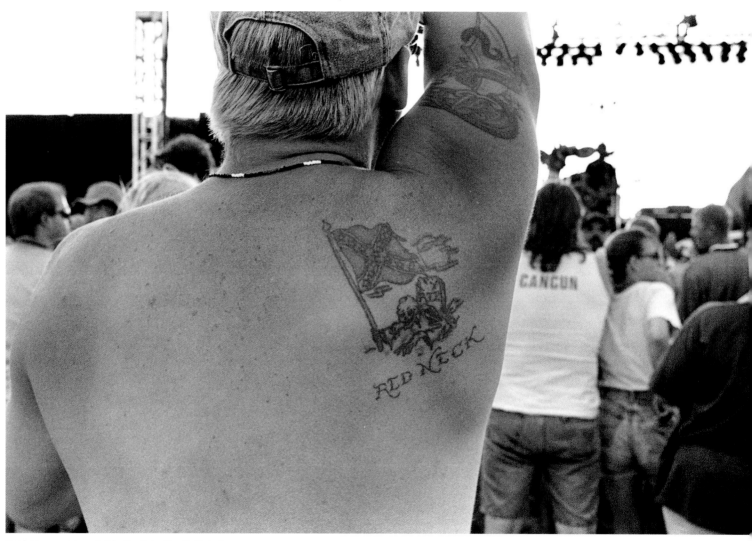

Foghat concert, outside Beulah, North Dakota

It was a truck-stop motel with dated furniture and an odd smell, like old fried fish. I asked the woman who checked us in how it was going. "Not so good. How would you feel if your son weighed five hundred pounds?" she said, then launched into a story about bringing her son to the hospital earlier that day. When we asked for a receipt she scribbled it on the back of a torn napkin.

The next morning we watched a black-and-white movie starring young Gregory Peck as a missionary in China. Hundreds of Chinese were in the movie, but only one had a speaking part—played, of course, by a white guy. I shot two rolls and started a shower. Before I finished Tara surprised me by yelling, "You've got to get in here. The *Psycho* shower scene is on!"

OREGON MOTEL

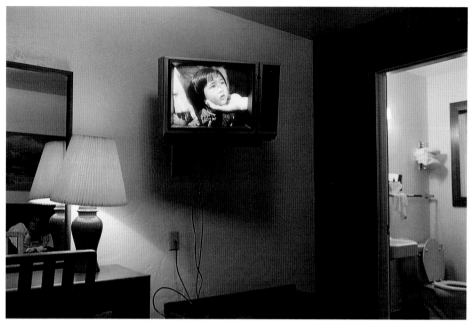

Coos Bay, Oregon
(The Keys of the Kingdom)

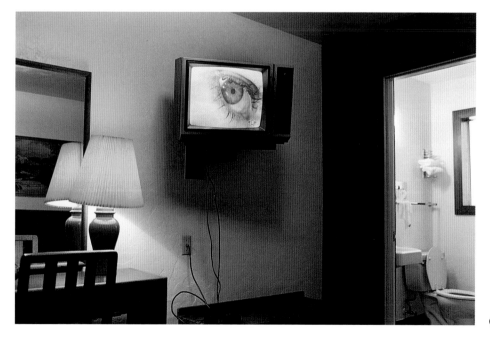

Coos Bay, Oregon *(Psycho)*

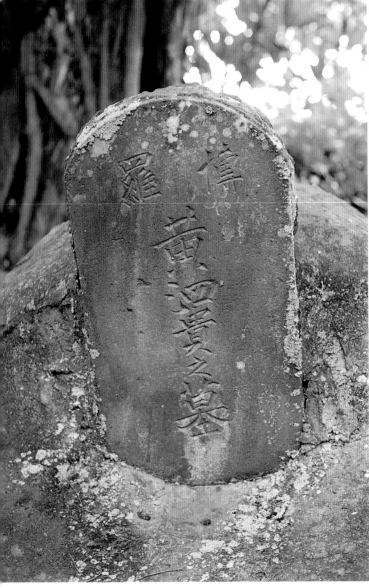

Unmarked Chinese cemetery, Big Island, Hawaii

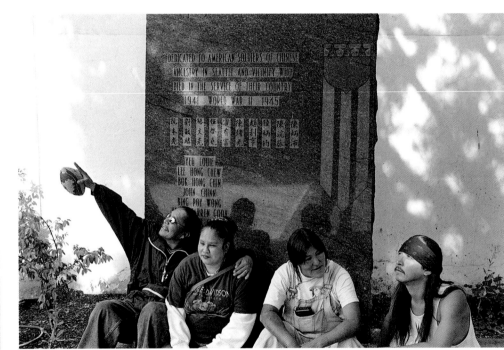

Chinatown, Seattle, Washington

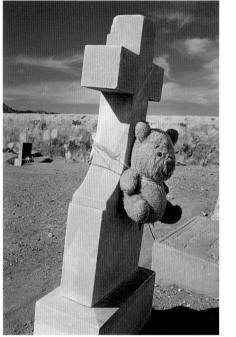

Cemetery, El Paso, Texas (Winnie the Pooh) Bar, Chinatown, San Francisco

I remember when I first heard the news. It shocked me more than any other celebrity death—even more than Lennon's, because Bruce's mortality was intertwined with my own. Nobody else in the cultural landscape so embodied my postpuberty fantasy of myself.

During the first summer after graduating from high school I was making good money cooking at the Chinese Lantern and everything seemed possible. A girl I was interested in told me suggestively that Bruce Lee was her favorite movie star. It was the most seductive thing she could have said to me. Years later I was playing pickup basketball with people I didn't know, and one guy kept calling me Bruce. I

BRUCE LEE wanted to punch him.

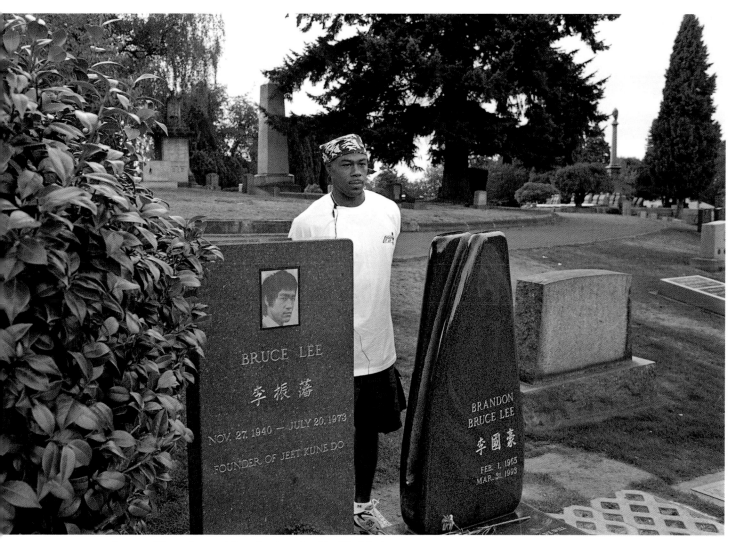

Graves of Bruce Lee and Brandon Lee, Seattle, Washington

Buddhist temple,
Richmond, British Columbia

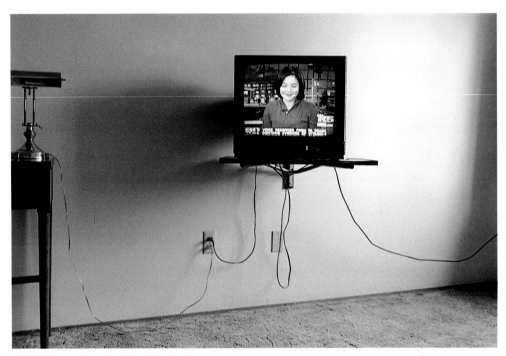

Television anchor, Seattle, Washington

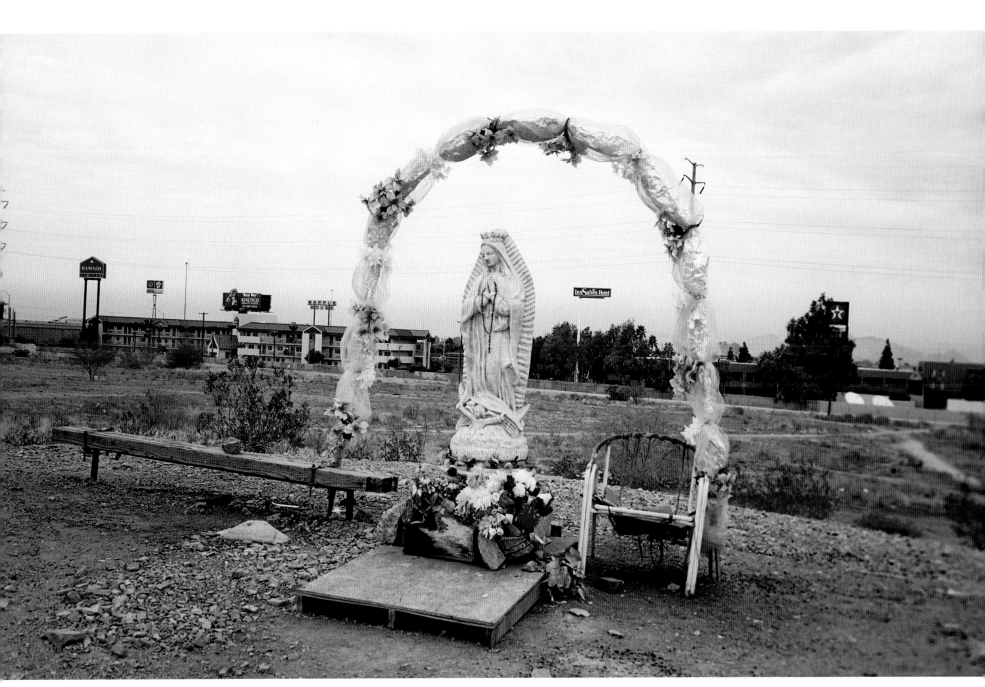

Guadalupe, Arizona

More than half of my first twenty-two years were spent in Chinese American restaurants, all owned by my family. I started keeping the books for my father at Joe Huie's Café when I was twelve. Later I cashiered, washed dishes, waited on tables, bused, and cooked. Working at my dad's, then my brother's, restaurant, the Chinese Lantern, was a major factor in making me who I am.

When I finally graduated from the University of Minnesota, armed with a journalism degree and photography skills, I spent another eight years tending bar in a Japanese place. At one point my mother suggested I give up photography and open my own restaurant. She even offered to front me the money.

I've eaten in hundreds of Chinese restaurants. It's what I do, especially if I'm in a new city. I like the ones with "authentic" Chinese food, of course, but I'm even more drawn to the chop suey joints, where the chow mein comes with crunchy noodles underneath—like the kind you got in the school cafeteria. The China Lantern in Carlsbad was like that.

Ping arrived from China at age eleven with "seven nickels" in his pocket. His mother, whom he left behind, called America the "Golden Mountain." Ping discovered differently: he wanted a career as an engineer and attended college briefly, but that privilege went to his younger brother in China, as Ping shouldered the responsibility of providing for the family, sending money and engineering books back to his mother and brother.

PING He opened the China Lantern fifty years ago and shortly after someone from town detonated a bomb in the restaurant. No one was hurt but the place was in ruins. Undaunted, and with support from the community, Ping reopened. He recently sold it to a couple who previously owned a Mexican restaurant. Half the menu is now Mexican food and the other half is Chinese.

Ping doesn't have to work anymore, but he still comes to the restaurant every day to cook during the lunch rush. He is legally blind, and in the dining room his blindness and age are apparent, but once he steps into the kitchen he is spry. As he cleans the bean sprouts and puts out the orders, methodically going about his familiar routine, the years seem to fall away.

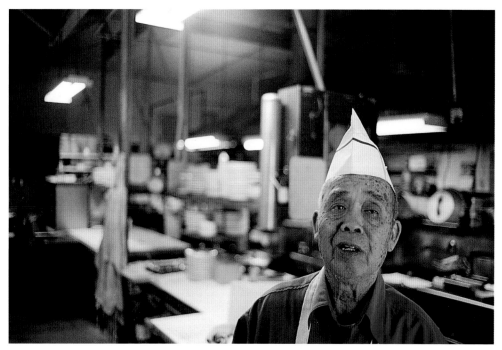

China Lantern, Carlsbad, New Mexico Ping, China Lantern, Carlsbad, New Mexico

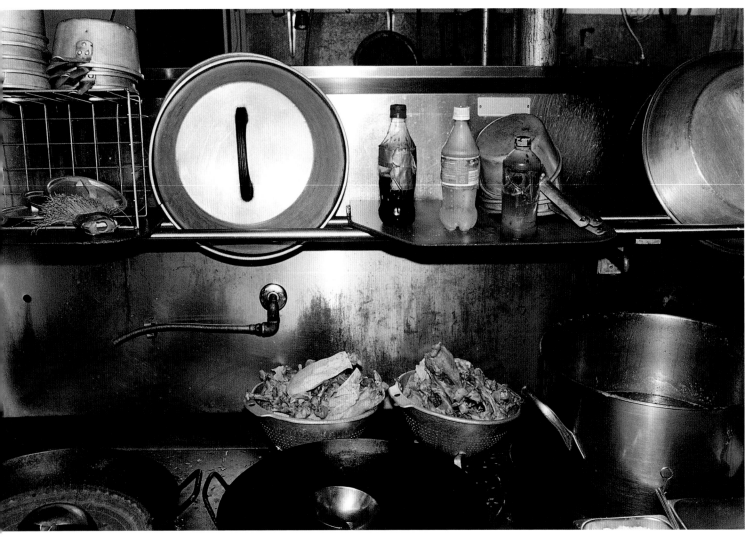

Ping's kitchen, China Lantern, Carlsbad, New Mexico

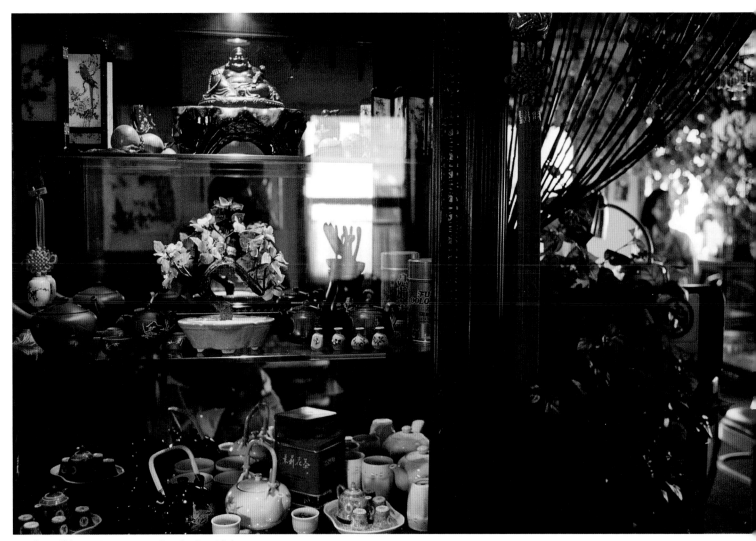

Bamboo Chinese Restaurant, Sandpoint, Idaho

Dragon Delight, Beulah, North Dakota

Jacksonville, Florida

Buddha, Splendid China Theme Park,
Kissimmee, Florida

We arrived in New Orleans, the site of several mega-events. The Super Bowl had been played a week earlier in the Louisiana Superdome and Fat Tuesday was just around the corner. And in Marrero, just twenty minutes southwest of the Big Easy, they were celebrating the Year of the Horse. The St. Agnes Le Thi Thanh Church had built an outdoor stage in its large plaza and brought in music groups from California. Attendance was in the thousands and almost everybody was Vietnamese.

This was a carnival feast with games, elaborate pageantry, and solemn ceremony, punctuated by the longest and loudest firecracker demonstration I've ever witnessed. From hip-hop youth to performers in traditional Vietnamese costumes to veteran soldiers in full regalia, the spectrum of assimilation was on display. We talked to one group of teenagers about what it was like living here. Saigon y'all, they called it.

One kid was wearing an infectious smirk and a T-shirt with VIP written in bold red. Underneath it read: Very Impressive Penis. "All of my friends are Vietnamese," he said. Why? "Because white people stab you in the back. Black people, too." He went on: "It's hard to succeed here. The schools are ghetto. All I learned in school

SAIGON Y'ALL here was how to spin a book on my finger."

When we asked these kids about their plans, they all immediately said, "Go to school and get a job." One wanted to be a nurse, another a chiropractor. The VIP kid replied, "I want to be a firefighter. I'm serious. Or Five-O."

Firecracker paper, Marrero, Louisiana

Year of the Horse celebration, Marrero, Louisiana

Vietnamese settlement, southeastern Louisiana

Demolition derby, Baker, Montana

Harvard Coalition protest, Cambridge, Massachusetts

It's not often you get to see a famous Asian guy in person. They're like white elephants, their value dubious or revered depending on the audience. This particular group of spectators at a brand-new Wal-Mart in Houston was enthralled: Martin Yan had come to town.

The charismatic star of the public television show *Yan Can Cook* and author of twenty-eight books cracked jokes like a burlesque stand-up and even did a Julia Child impersonation, all the while demonstrating the intricacies of making Seafood Trio in Kung Pao Sauce. At one point he gestured to the front-row Chinese ladies and declared, "These are all my relatives. We come from the same village!"

The highlight was when he deboned an entire chicken in eighteen seconds. After a lengthy buildup as he humorously massaged the raw carcass and then banged his utensils like a Stomp musician, he managed the feat in fourteen. When he held the extracted breast aloft the crowd cheered as though it were a dragon's head.

That scene had personal resonance for me. When I was wooing my future wife with my stir-fry skills (my chicken, mango, and hot peppers rocked) I bragged that I could debone a chicken in one minute. She didn't believe me. We now joke that it was the coup de grâce of my courtship. All those years as a Chinese cook finally paid off.

MARTIN YAN

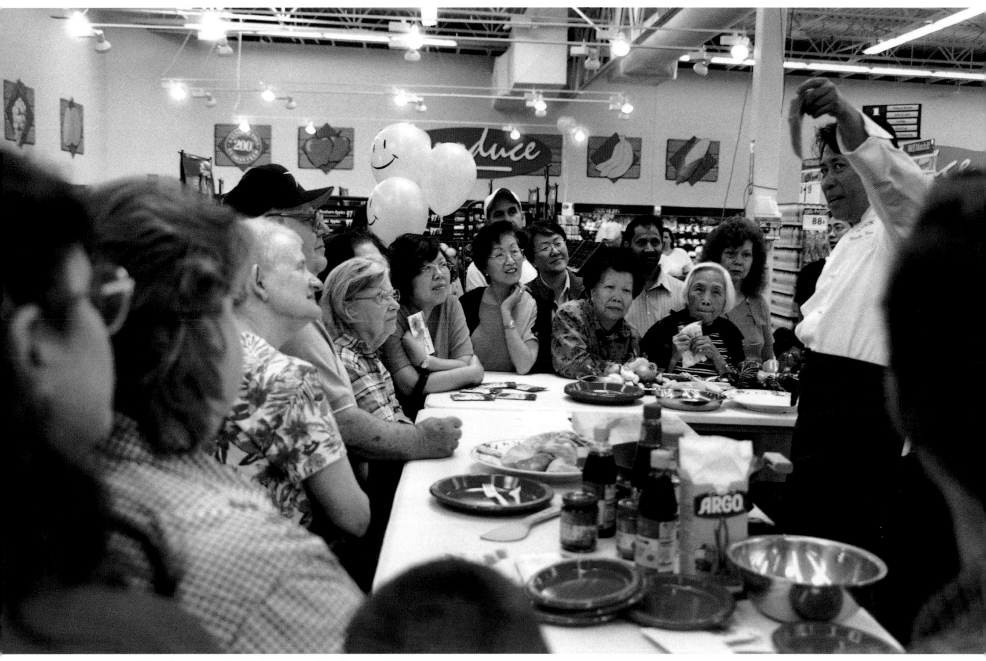

Martin Yan demonstration, Wal-Mart opening, Houston, Texas

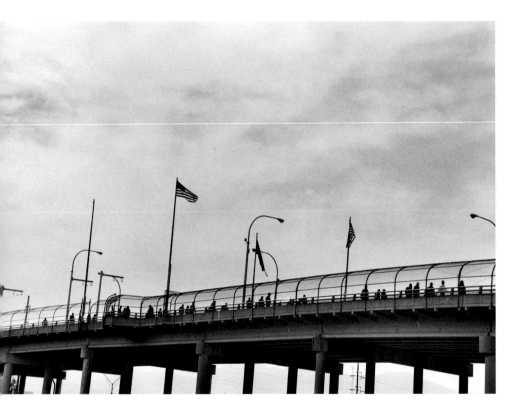

The bridge connecting El Paso, Texas, and Juárez, Mexico

Natchez, Mississippi

Somewhere in Texas

Wenatchee, Washington

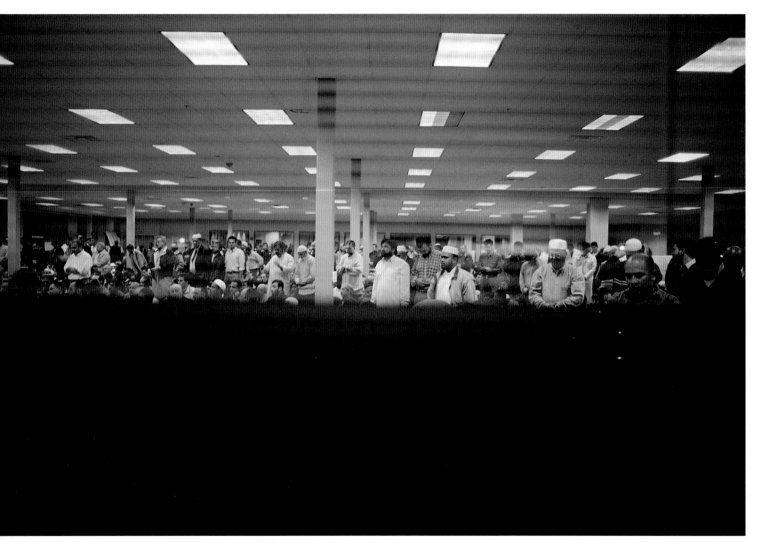

Muslim Community Association, Santa Clara, California

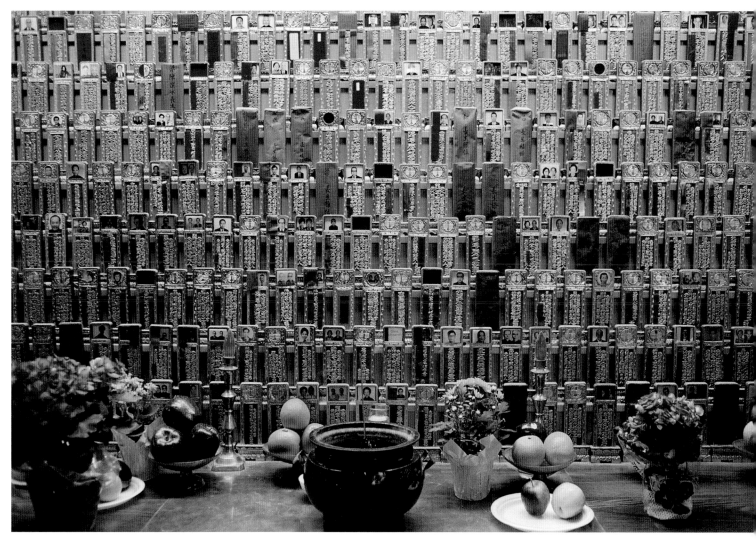

Memorials, Buddhist temple, Richmond, British Columbia

We were at an antique store in Hilo when someone suggested we talk to Steamy Chow, a retired police officer and a living legend. We immediately called from a phone booth just outside. His wife, Lilly, answered and graciously invited us to their home for breakfast the following morning. Amazing. We had just pulled in, total strangers, and now we're having breakfast with a living legend named Steamy.

Steamy and Lilly, both retired, have spent their entire lives on the island of Hawaii. Lilly gave us a tour of their house, which was spilling over with four Christmas trees and ornaments everywhere. It was October. Thirteen years ago she had had surgery and didn't have the energy to take down the trees—so they stayed, permanently. Friends and family send ornaments from all over the world. "It's so beautiful to have Christmas all the time," she said.

Steamy regaled us with detailed stories of the area. His consuming passion has been to collect oral histories from the survivors of the tsunami that struck the Hawaiian Islands in 1946 and killed 159 people. Because of his dedication to preserving history, the County of Hawaii officially designated him a "Living Legend."

During our breakfast of scrambled eggs and fried Spam (a Hawaiian staple), they told us what it was like growing up in Hawaii. "When we were children we had our cultural fights," Lilly said. "People would poke fun at the Chinese because they thought that we were always after money. They would say 'Ching ching Chinamen, sitting on a fence, trying to make a dollar out of fifteen cents.' To the Japanese kids we would say 'Stink daikon,' because they ate daikon radishes. To the Filipino kids it would be 'Oh, you poke knife all the time,' because they were always fighting with knives. And to the Portuguese it was 'No washy wash,' because we didn't think they took a bath every night. We were terrible to each other.

"I think after our generation there was so much intermarriage that that separateness just faded away. I'll tell you something funny. My youngest son was at a nursery school and after Christmas the teacher, who was Japanese, greeted every one of the kids by saying 'Happy New Year' in their native tongue. When she said 'Gung Hay Fat Choy!' to my son, he turned to her and said, 'I'm not Japanese, you know.' He didn't even know it was Chinese."

LILLY AND STEAMY

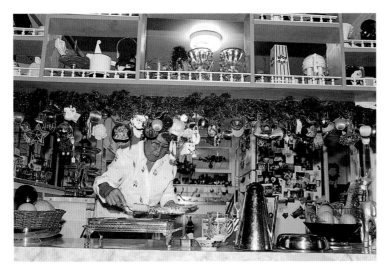

Lilly, Hilo, Hawaii

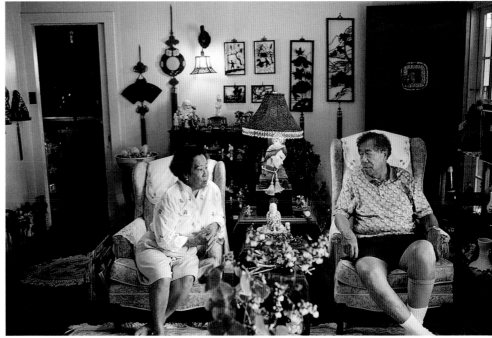

Lilly and Steamy, Hilo, Hawaii

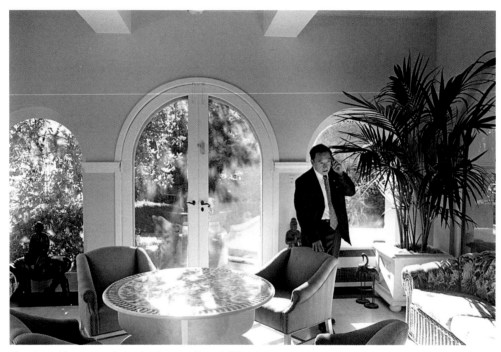

City Councilman Matthew Lin, San Marino, California

Year of the Horse celebration, Marrero, Louisiana

"Man Sees Image of Elvis on Tree" read the headline. The article in *Texas Monthly* was only one paragraph. The man was identified as the president of the Asian Worldwide Elvis Fan Club. We looked in the Yellow Pages, made a call, and the next day found ourselves in a fantastical Elvis shrine masquerading as a modest suburban rambler.

As we drove up, the first Elvis we saw was emblazoned on a huge Stars and Stripes in the front yard, next to a ten-foot replica of the Statue of Liberty. Henry and Tania came out to greet us in their entertainer blazers and fan club T-shirts. When we entered through the garage the sensory overload began. Every square inch of space seemed dedicated to the King. Going to Graceland two weeks later was anticlimactic.

Henry and Tania, both Vietnamese immigrants, were inspired by the story of a poor, backwoods outsider overcoming his circumstances to become a global icon. They have spent most of their time and money emulating and celebrating that achievement.

ELVIS Their son John, whom they soothed with Elvis lullabies as a baby, took second place in an international Elvis impersonation contest in Memphis. Henry is not an Elvis impersonator, but he did sing quite a variety of songs for us, including a country western tune, a blues song, songs in Moroccan, French, and Spanish, and, of course, one by Elvis. Everything except a song in Vietnamese.

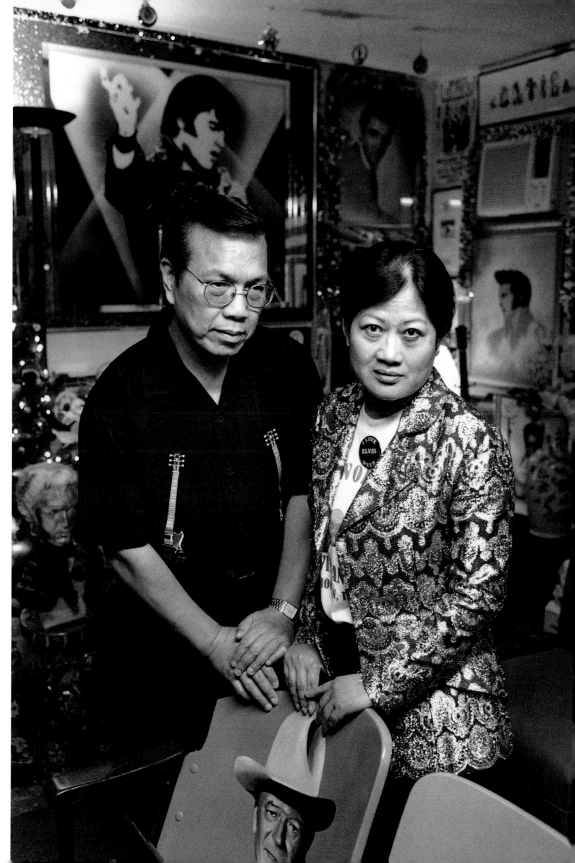

Founders of the Asian Worldwide Elvis Fan Club, Houston, Texas

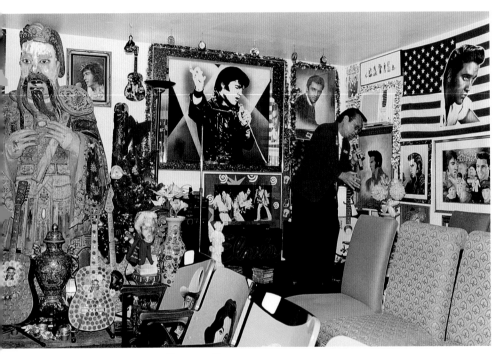

Henry, Houston, Texas

Gift shop, Chinatown, San Francisco, California

Bruce Lee dolls, Chinatown, San Francisco, California

Newsstand, Chinatown, San Francisco, California

On first impression, Molokai, the least-visited Hawaiian island, seemed like a big rock covered with scrub trees and red dirt. We left our car at a lookout point and went for a walk, out in the middle of nowhere, and we stumbled on an isolated enclave of houses. In front of one modest home was a tiny handwritten sign that read "pottery for sale." Intrigued, we went closer and were startled by the bizarre sight of the garage, which was festooned with dozens of horns and antlers.

Just then, the door opened and out came a small woman who asked sweetly, "Would you like to come in?" Gladys showed us into a one-room studio adjoining the house that was filled with hundreds of her hand-painted items: Snow White and the Seven Dwarfs lawn ornaments, Nefertiti busts, Japanese beckoning lucky cats, condiment dispensers with Molokai written on them (we bought one), Mickey and Minnie, unicorns, penis cups (tourists love them!), and on and on.

Afterward as we sat at a table in front of the house and sipped tea with Gladys, I asked her about the antlers. "I'll let my husband talk about that," she said, and then hollered, "Ron!" He emerged from the house, filling the doorway.

"Are you the hunter?" I asked.

"I'm a lover, not a fighter," he responded, laughing.

MOLOKAI

We proceeded to "talk story" the Hawaiian way the rest of the afternoon. They told us about big game hunting in Africa, coaching championship Little League baseball, taking in friends of their kids who were in trouble, and the challenges of growing up in Molokai as an ethnic minority (he's a blend of Portuguese and Filipino, she's one hundred percent Japanese). As we were leaving Ron said, "Next time you come back we'll go hunting. I'll show you how to kill a wild boar with a knife."

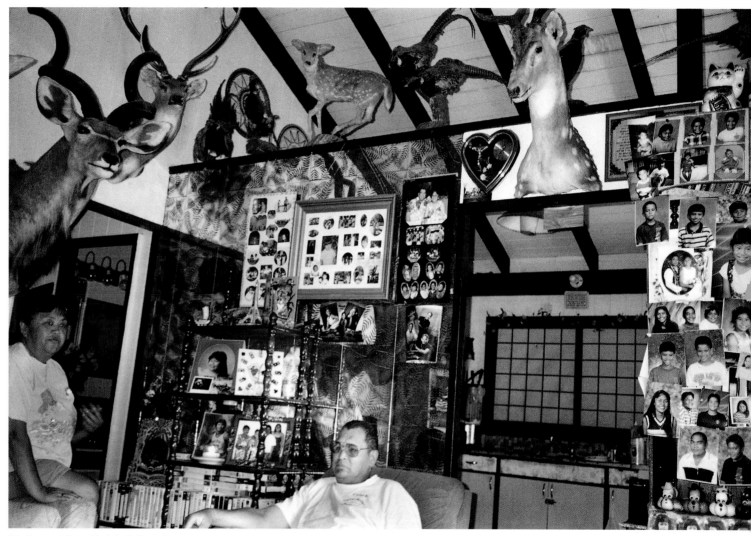

Gladys and Ron, Molokai, Hawaii

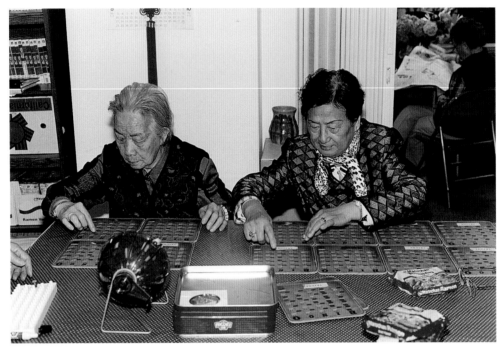

Senior center, Seattle, Washington

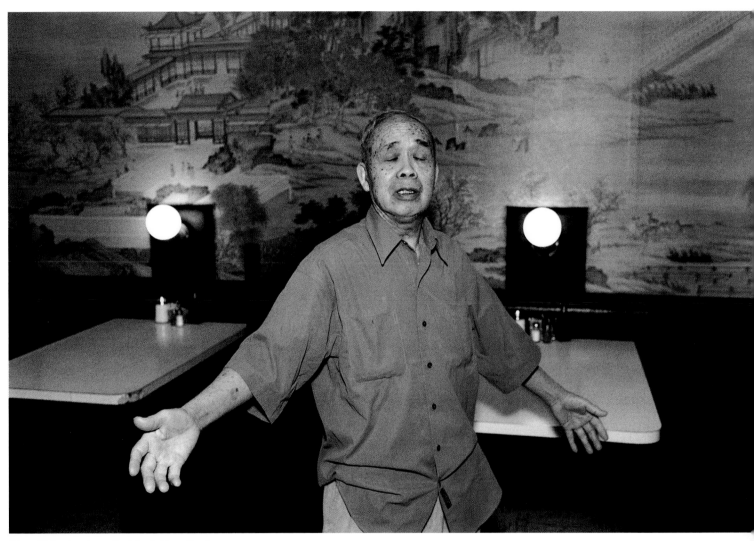

Ping, China Lantern, Carlsbad, New Mexico

Just down the road from Sea World and the Magic Kingdom was Splendid China Theme Park. "Our 76-acre park features the magnificent work of more than 120 artisans and craftspeople from China . . . recreating 60 of the wondrous sights—in full scale and miniature—of one of the world's oldest civilizations" read the brochure. Experience China in one day was the idea, I guess. The first Splendid China, built in Shenzhen, Guangdong, was such a success that it was imported to the land of Disney.

I've never been to China, so the idea of home has always been a curious thing to me. I am the youngest in my family and the first of the Huie lineage not born in the Middle Kingdom (China has always thought of itself as the center of the world). Instead, I was conceived in the land of the Vikings. Telling strangers where I'm from is often puzzling to them, because Duluth, Minnesota, doesn't jibe with their image of who I am. They want to know what province or rice paddy I call home.

With these thoughts in mind I entered Splendid China. I love theme parks and this was one of the best I've ever visited. There was a great blend of awe-inspiring, educational, bizarre, and kitschy sights. The Great Wall stretched about the length of a football field. The Chinese food was disappointing, but the whole experience spurred my desire to go to China even more. The next day Tara and I debated whether we should go to Universal Studios or to the home of the mouse.

SPLENDID CHINA THEME PARK

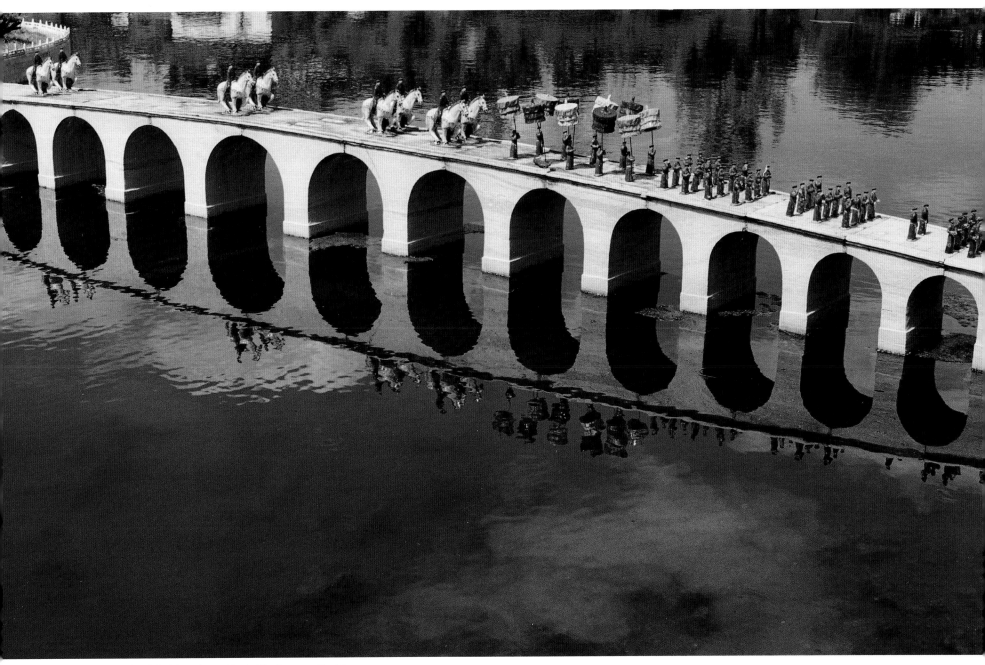

Splendid China Theme Park, Kissimmee, Florida

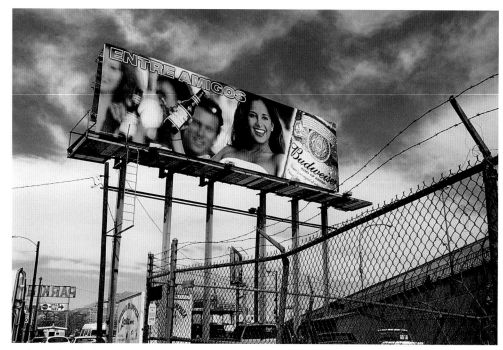

At the end of the bridge connecting El Paso, Texas, and Juárez, Mexico

Chinatown, San Francisco, California

Alhambra, California

"What kind of Asian are you?" is a game Asians often like to play in their head when they see other Asians in public. It's a conceit that we can guess someone's ethnicity and immigrant status by the way they look—that we can tell, for instance, if so-and-so is FOB (fresh off the boat) or ABC (American-born Chinese).

I think I'm pretty good at it. There's a web site that tests your ability to photographically identify the ethnicity of eighteen people of Chinese, Japanese, or Korean descent (alllooksame.com). The average score is 7, and I got 11. "You've got talent," the site said.

So I was surprised when I met Juxin, a seventeen-year-old girl who was born and raised in rural Montana. We were in Forsythe, somewhere between Miles City and Billings, sitting at the Hong Kong Restaurant. The owner, Judy, was telling us that she and her husband picked this place because it was so isolated. It was the only Chinese restaurant for several hundred miles. They are also the only Chinese people for several hundred miles.

They like it here but sometimes it's tough for their daughter, Juxin, who is very shy. So shy, in fact, that in her first four years at public school she didn't speak. Not to teachers or to any students. Her parents even sent her to a psychologist, who said that there wasn't anything wrong with her.

JUDY AND JUXIN

Later that day, after school was out, we met Juxin. She spoke so softly that I could barely hear her even though I was sitting just a few feet away.

Everything about Juxin's demeanor and appearance made me think she was FOB, like her mom. She looked like she was from another country and that a part of her had never left. She's always been nervous around people, she said, and she felt that her being Asian maybe made people look at her differently. But then last year, for some reason, she gained more self-confidence. "When people get to know me," she said, her voice rising slightly, "they realize I'm just like everybody else."

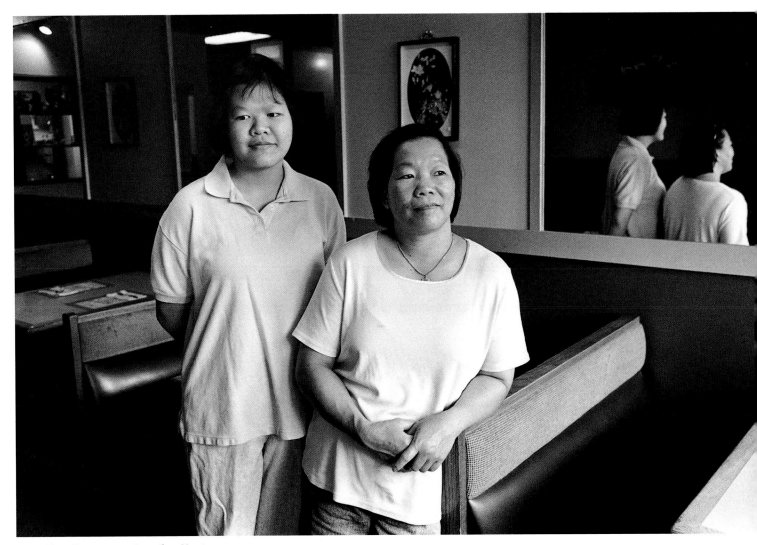

Hong Kong Restaurant, Forsythe, Montana

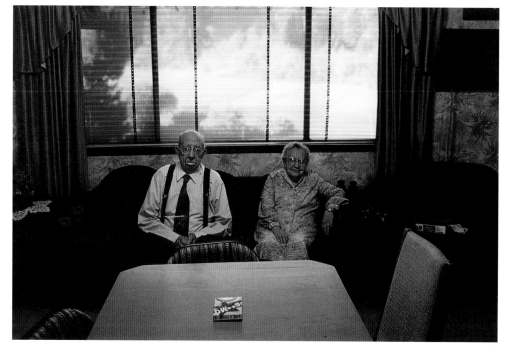

Leavenworth, Washington

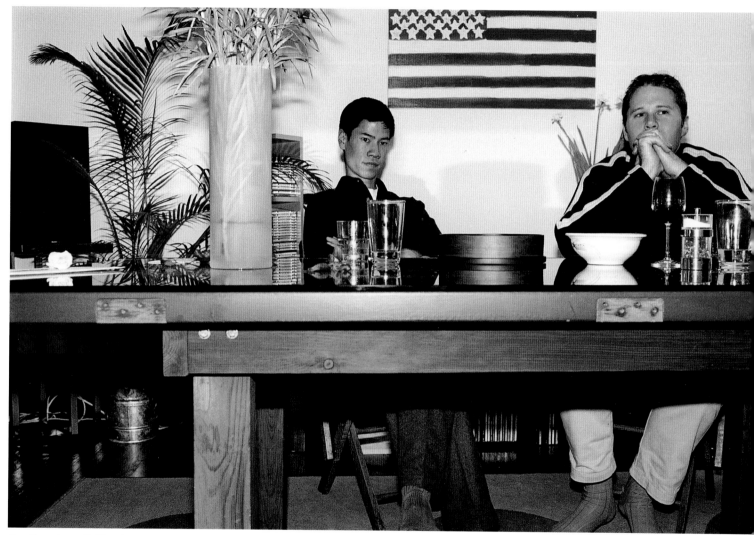

San Francisco, California

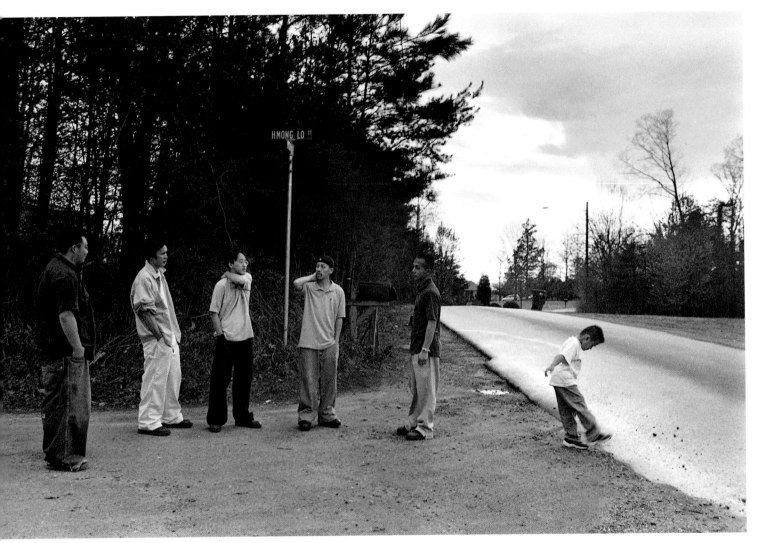

Hmong Lo Street, Hickory, North Carolina

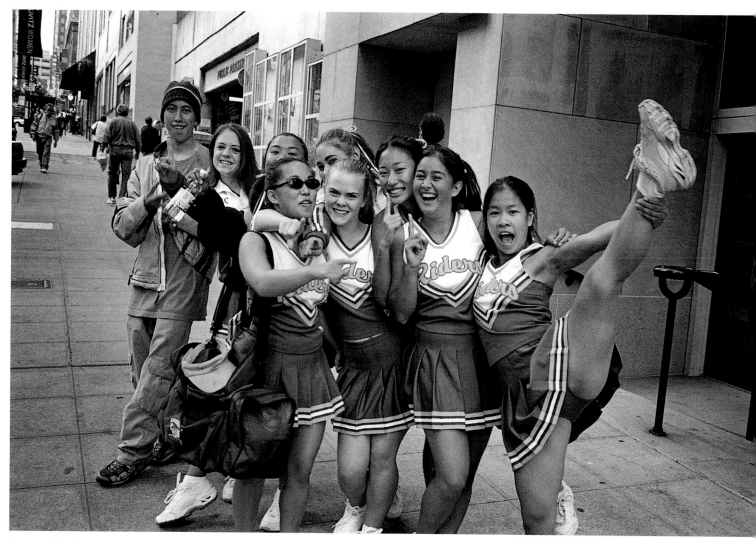

Seattle, Washington

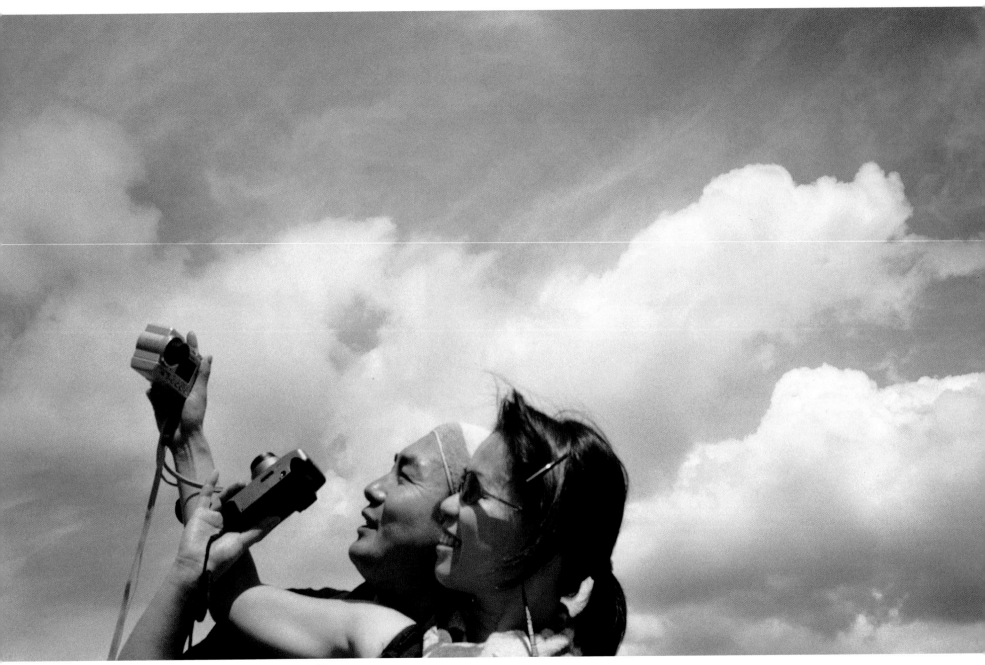

Diamond Head Crater, Waikiki, Hawaii

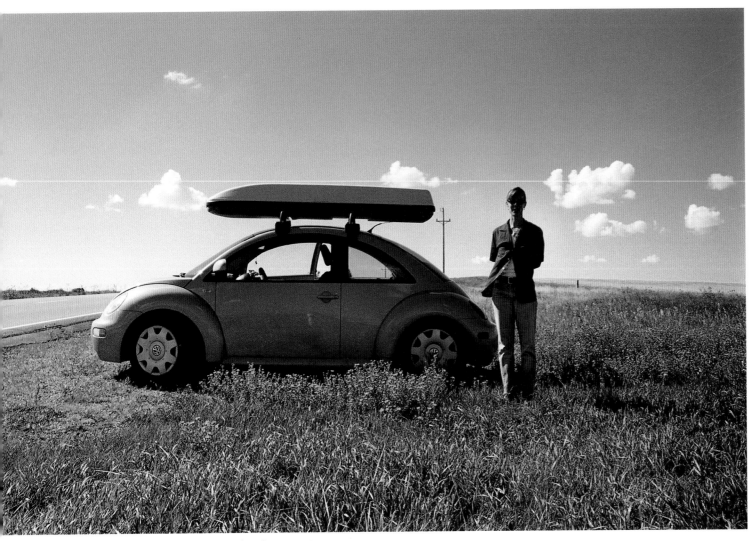

Tara, Highway 2, North Dakota

VIEWS FROM THE ROAD

TARA SIMPSON HUIE

"It will be very important for you to write down your thoughts and impressions while you are traveling." My astrologist relayed this to me the week before Wing and I left on our cross-country road trip. But I don't write, I thought to myself: my mother, stepmother, older and younger sisters write, but not me. I can hardly spell.

I am dutiful, however. And as our trip eased into its first few weeks the pressure to follow through on my task far outweighed my own self-consciousness. "Views from the Road" started as a way for me to pass time in the passenger's seat, my preferred writing space, but instead of feeling dutiful I was enthralled and motivated as lists of thoughts, events, and places stretched out into sentences reflecting on all the things that happened while the lenses were dark.

THE ROAD AHEAD

The car had bad feng shui. That's all there was to it. After hours of packing we now had to discuss what to leave, how to reorganize. When we pulled into my parents' driveway in Golden Valley, a suburb of Minneapolis, we began tossing things out, even ditching the bikes. Wing took one glory spin on his new bike, then parked it in my parents' garage for the year. The cooler, tea and accessories, my wicker bag—all got the big hook. The basketball and my black boots made it, a very good thing.

Our stomachs were upset—an emotional, stressful day—and now we were headed for Duluth. We decided to keep track of a few bizarre statistics: how many pieces of pie we eat, how many beers, how many gallons of gas we use. I'm sure we'll think of more as this adventure unfolds.

We listen to tapes we recorded, talk a little, and just let the car lull us into the reality of our new life. Together and on the road.

ROAD TO NOWHERE

"We're on the road to nowhere . . . " The Talking Heads song was playing in our heads as we pulled onto Highway 83, heading south. What beautiful country. We stopped once to take photos of the landscape and then a second time to take our photos in shoulder-high sunflowers. It was going to be a pokey day.

We pulled into Beulah, North Dakota, and got the last room at Dakota Farms Inn. Party on the Prairie, a rock concert featuring April Wine and Foghat, had attracted three thousand people. Beulah was bursting at the seams.

The next day we went to Connie's Coffee House. Connie, the bigger-than-life personality behind the counter, served our morning brew. Her hair was sculpture, highlighted blonde and whisked back with at least a palmful of super-hold gel; it spiked in all directions and no Dakota wind could take it down. She brought us up to speed on the goings-on in Beulah. We had come to the right place.

Connie told us about Dragon Delight, the only Chinese restaurant in town. One of the waitresses, Sandy, had been in Beulah only eight days. She had come from San Francisco Chinatown. Wing asked how many Chinese were in the area. After a big pause Charlie, one of the cooks, looked around and said, "Four. One, two, three, four—there are *now* four Chinese people."

A pattern is emerging. I videotape while Wing asks questions and takes photos. It's fun, as long as we don't get in each other's way. "Hey, you're in my shot!"

It still amazes me how quickly he gets into people's homes or businesses, how much

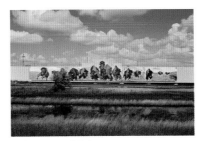

Highway 2, North Dakota

they tell him and how much they let him see of themselves. I feel nervous or uncomfortable much more quickly than he does—if he does. But it takes time for what is natural and true to show itself, and I am learning to be patient.

PARTY ON THE PRAIRIE

The Party on the Prairie was calling. We drove a couple of miles beyond Beulah, where a long line of trucks, campers, and our lone green Bug waited to enter the city of RVs, American flags, cases of beer, and at least two six-foot inflatable penises. In the world of hard rock one thing never changes: fashion. Cutoff tees and ripped jeans, bandanna halter tops, Daisy Dukes, and—always—a cool pair of shades.

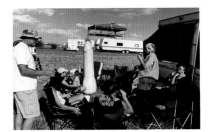

Party on the Prairie, outside Beulah, North Dakota

We walked around, then found an Indian taco stand. We should have asked before we ordered two. Down came the weight of Indian fry bread on the thin paper plate, two spoonfuls of taco meat, onions, tomatoes, grated cheese, three big squirts of sour cream, and finally a dose of salsa.

We had to walk it off. As we toured the vendor stands, I spied a huge, burly, tattooed man with a thin, long leash leading

to a Chihuahua. I sent Wing over to ask him if he could take his picture. Not only did he comply but he brought out a box holding seven baby Chihuahuas. Have you ever seen a baby Chihuahua? It's almost too much. "They travel well," he informed me. He knew who the softy was. We came very close to taking the little black and white pup. Day six and we pick up a pet.

After several hours of hard-rock guitar riffs we were ready for the quiet comfort of the Bug. The ride to Dickinson was west, heading into the setting sun. With cool shades on and the radio set to piano jazz—in the middle of North Dakota—we made our way to the Oasis Motel to scrub off the day's dust.

MENNONITES IN THE PARKING LOT, DICKINSON, NORTH DAKOTA

Wing woke up early and went out to wander around. He met a lonely cocker spaniel in the parking lot and returned to grab his camera gear to take photos of his new friend. Not long after, I was lazily making a cup of coffee when Wing came rushing back. "There are Mennonites in the parking lot—grab the video and come down as soon as you can!"

Yes, there were seven kids in the parking lot eating doughnuts, with Wing snapping shots right and left. The mom and daughters were in traditional dress with white caps while the boys and men looked like regular farmers. Indeed, that is what they were, migrant farmworkers from Minnesota. They own a farm but make more money traveling the five-state area during summer and early fall to harvest other farmers' wheat.

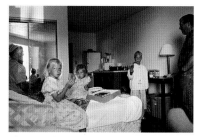

Migrant workers, Oasis Motel, North Dakota

The girls were towheads right from *Little House on the Prairie.* They were as interested in us as we were in them, so we spent a good hour or more talking, showing them Wing's book *Lake Street USA,* and videotaping. The mother tried to explain the religion of the Mennonites as it compares to Lutherans or the Amish. She became teary-eyed talking about it. "Are you Christians? You seem so nice, you must be." A long pause. Wing and I tried to communicate by telepathy at that point. We gave her a historical account of our experiences with religion rather than a direct answer to her question. She liked us anyway.

PITCHFORK FONDUE

The butte that overlooks Medora, North Dakota, includes an incredible overlook into the Badlands. We saw hundreds of people in line—I mean, *hundreds*—along the edge of the butte gathered for the well-known feast preceding the Medora Musical. Pitchfork handlers started doing their work: 12 steaks to a fork, 65 pitchforks lined up, 780 people fed in less than 45 minutes. They unloaded a tender steak, hot and still sizzling, from the fondue vat onto your plate. You finished it off with slaw, beans, fruit, and veggies—a regular

cowboy luau. The beans rivaled Mom's, and for dessert there was a huge double chocolate brownie. We saved one for breakfast the next day.

We sat at an outdoor picnic table watching the sun go down and kept quiet company with the older couple across from us. The gentleman struggled a bit with the cap on the Heinz 57 bottle and it landed in his coffee cup. He fished for it unsuccessfully with his fingers. I couldn't stand it anymore and tried search and rescue with my spoon. They were thankful and it broke the ice.

They come to the musical every year—or rather, she comes to the musical and he gets dragged along. We were about done with our meal and the man hadn't said a word. Then his wife asked us where we were headed. The story of the big trip was told once again. He spoke. "Boooy, whiiin yu deeecide ta traaaaavel, ya rilly traaaaavel." He rarely spoke, but he spoke the truth.

THE TOWN WAS CLOSED

There really is something to rolling out of your sleeping bag, wiping the sleep from your eyes, and looking at the sun warming the world into a new day. Everything seems more vivid and beautiful. I wish I had found the right coffee-pot before we left: this morning called for cowboy coffee. Instead we broke camp and ate granola bars and drank mochaccino from the convenience store.

Tummies refueled, we took a dirt road through Slope County. According to the 2000 census it is the least diverse county in the United States, with three nonwhite residents.

We were going to try to find one of them. It soon became apparent that we were not going to find anyone on this road, just sagebrush and a few cows. So we kicked back, drove at max speed (thirty miles per hour), and soaked up the scenery as we made our fifty-five-mile journey to Amidon, North Dakota, the smallest county seat in the country.

The town was closed. After our long, hot, *slooow* journey we couldn't even buy a soda to rinse the dust off our teeth. Wing was in a funk. Disappointed. Then we spotted a sign for an antique shop and campground. A short, stocky, bristly-haired old man opened the shop. Wing had been rehearsing nonthreatening ways to ask about the level of diversity in the area. He was quiet. I could tell he didn't like the guy much. Wing doesn't react that way too often. I spotted an antique mah-jongg set, all bamboo and ivory. I was surprised. But it gave Wing an in: "Were there Chinese around here or something?"

"No," the man said, as if he knew what we were trying to get at. "No Chinese here and no *others* either. The papers said there were three non-Caucasian folks but none of *us* know where they are."

We passed on the mah-jongg set and decided to move on. You can't plan a trip like this or expect to find things in a certain place. I had the feeling we were looking too hard.

DEMOLITION DERBY

Marmarth is even smaller than Amidon. There's not much there, but the restaurant seemed liveliest. A large man with flesh-colored growths covering his face and arms was sitting at a table swatting flies, four teenagers were eating burgers, and another couple sat content not talking to each other. We sat down in the middle of local scrutiny and ordered a side of fries. In a small town if you wait long enough, people start asking questions. "Where ya headed?"

"Well, we're not sure." It's a conversation starter. Everyone got into suggesting where we should head next, except for the man with the flyswatter. He kept quiet and focused on decreasing his insect population. They told us about the Baker County Fair (just across the Montana state line), a big deal in the area with rides and 4-H competitions. The demolition derby, a real crowd-pleaser, was the final event and not to be missed.

Neither of us had ever been to a demolition derby and didn't know what to expect. Everything in Baker was closed and we had a hard time finding our way. A one-eyed, smoking cowboy finally pointed us in the general direction. The whole town was piled into the grandstand bleachers. I grew faint. I wanted to sneak in, sit on the grass, go unnoticed. But Wing wanted to be in the thick of it, and the two of us stood in front of the bleachers—in front of the town—searching for an empty space to sit. Five rows up in the middle he found a place. "Pardon me, 'scuse me, hi, just trying to get over there, thanks."

Here's the basic gist of a demolition derby. When the flag drops, the cars start driving back and forth, ramming into each other as hard as they can until there is only one car left running. It has to be able to move. The

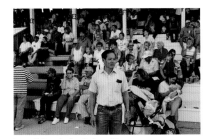
Demolition derby, Baker, Montana

only rule is you can't hit the driver's door, but anything else is fair game. Oh yeah, and you have to wear a helmet. It was nuts. I learned all of this from the cowboy sitting next to me. As Wing puts it, he took a shining to me and talked my ear off the whole evening. He even talked to the derby guys and got Wing a prime spot to shoot from. I didn't get his name.

I lost track of Wing for a while. Then he showed up with another Chinese guy. Go figure.

FLYING MOTORCYCLE

I've seen a lot over the years; Wing, even more. But both of us sat stunned and confused this morning in Miles City, Montana, as we sipped coffee and watched a man sail over us on a motorcycle. Yes, a motorcycle. I heard him before I saw him—put, putt putt, put-pop. He seemed to have rigged a parasail to a motorcycle and was touring downtown from about 150 feet up.

No one around had seen him or knew anything about the flying motorcycle. I thought maybe there was some loony local who was a town legend—"Oh, yeah, that's just Frank." But no. We were left to wonder.

THE MONAD

Livingston, Montana, according to *Road Trip USA,* is a town with an Old West feeling, a rough-and-tumble town. Either we were there on a sleepy afternoon or they're just using that as a tourist ploy. Livingston was more cute than crotchety and more touristy than tough. I sat in a coffee shop to write while Wing took off to check out a local Chinese restaurant. This would be the first and last time I didn't accompany him. I *hate* missing out.

As he tells it, the owner wasn't in, and the girl working the front had quite a story to tell. The restaurant sat on top of what was once the underground railroad, where Chinese railroad workers gathered to socialize and smoke opium. We later heard these tunnels were a getaway from police who were trying to bust the opium dens. It looked like a big old cellar to Wing but the girl was clearly unnerved just being down there. Evidently, it was haunted.

We decided to get some facts and headed to the railroad museum. We peppered the poor docent with questions as soon as we entered. "What do you know about the Chinese underground railroad?"

"Uh, I've never heard of that."

"Well, what about the Chinese railroad workers in the area?"

"Hmm, well, I'm not sure."

"Oh, and why do you have some signs in Japanese, and isn't that the yin yang symbol? How did that become associated with Northern Pacific Railroad?" This woman looked like a deer in the headlights—she couldn't answer one of our questions.

"Let me call the museum manager and have her talk to you." So we poked around while we were waiting. One photograph of Chinese workers in the whole place, *one.* As Wing said, the railroad was built on the blood of the Chinese and there's not a hint of recognition. Not even in 2001.

When the museum manager arrived she was able to answer some but not all of our questions. The yin yang symbol became the logo of Northern Pacific Railroad after the owner and visionary of the railroad went to China in his travels. The railroad was faltering and needed an image boost to bring in more money. He thought the meaning of the symbol and its place in Chinese culture fit perfectly with what his company was trying to do; how he came to this was unclear, but he appropriated the symbol, changed its name to the monad, and printed and distributed his explanation of its significance to the public.

The museum manager contacted a newspaper reporter who had researched and written about the Chinese in Livingston. She would meet us the next day for coffee and would see if her husband could join us. He worked for the railroad—and oh, he's Chinese.

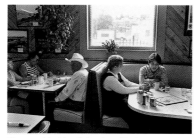

Elmer and Larkin, Livingston, Montana

HUTTERITES AT THE HOT SPRINGS

Around the pools of White Sulphur Springs, Montana, were several women speaking German. They wore layers of differently patterned clothes and polka-dot bonnets that reminded me of the Amish. While I was changing, I began to talk with one of the women. They were Hutterites, a religious group that settles colonies all over the United States.

I watched her do her hair as she talked. She had long, long hair. The back section was twisted, then wrapped around some sort of pin. Parted in the middle, the front sections were twisted under or toward her face, then the twist was brought under her ear and around the bun in back. The bonnet hid all the hair except the very front section. It was fascinating to watch.

They had just harvested corn today and were in town for the sulphur baths and various doctor appointments. We enjoyed a really nice conversation and, feeling bold, I asked if we could come out to their place. She said yes.

It took us a couple of tries but we finally made it across the valley to this colony of 130 people. I didn't know the woman's name but she had said her family sold vegetables and pickles and anyone could direct me to their store. The homes were almost barrack-style buildings with individual but identical porches and clotheslines outside. The people all had heavy accents but perfect English, and everyone was dressed alike. Later we found out they learn German before English.

We went to the store, a shed on the edge of their property where they sold their goods. I did not see the woman I met anywhere. We opened the door and a small mob of little girls came running toward me.

"Hello, what is your name? What would you like?" They all wore miniature versions of the woman's outfit. The boys were in charge of the store and the money. They wore bright patterned shirts with straw cowboy hats and leather cowboy boots.

The girls were intrigued with Wing and swarmed around him while I shopped—corn fresh picked, beans, pickles, and cherries in heavy syrup. When I emerged from the cooler, Wing was jumping up and down, as were all the girls. Okay, what just happened? When they asked him what his name was, he said, "Wing, like a bird's wing," motioning with one bent arm.

"Can you fly?" the girls asked.

"No," Wing replied, "but I can jump!" And so they jumped after him as we walked around the shop.

Then the woman from town found us. She brought her sister and daughter to introduce to us, and showed us the leather shop. Her name was Lena, her daughter's name was also Lena, and her sister was Annie. The leather work was beautiful and, surprise, I bought a purse and Wing, a wallet. They let us take a couple of photos but we could not use them for publication or show. But they loved Wing's Lake Street book of photographs of people in Minneapolis.

It was hard to leave. A bell rang and everyone needed to go somewhere, but I could tell Lena didn't want us to leave. She said she wished she had more time to show us their garden, the school, everything. It's amazing how you can come from such different worlds and still connect deeply with someone you don't even know. We said goodbye.

COWBOY COFFEE, BIGFORK, MONTANA

Cowboy coffee means different things to different people. To me it's about physics and the prairie. My first encounter with true cowboy coffee was on a leadership training week in the Badlands, not far from where Wing and I camped. My advisor started the morning with this wicked brew: Pour grounds into a kettle with a lid and a handle arching over the top. Fill with water and simmer. You know it's done by how it smells. Take it off the fire, stand up, and with surefire determination swing it around and around at least three times. Do not hesitate. The centrifugal force keeps the lid on the pot and sends the grounds to the bottom. Drink. It's an impressive, full-flavored way to start your day.

HUCKLEBERRY PIE

We came to the little cowboy town of Hungry Horse, Montana, which boasted it was "The best *DAM* town in Montana." Not only did it have a dam but also the first huckleberry pie stand we had seen. We swerved into the parking lot for a late morning snack. Wing had never tasted huckleberries and I tried to explain they were like small, tart blueberries but even better.

During summers while my cousins and I were growing up, we would go into the Idaho mountains with my grandparents to pick huckleberries. Two for the mouth, one for the bucket. It's a wonder Grandpa ever had enough to make a pie. Wing and I bought a jar of pie filling at the stand just in case we didn't find any more along the way. One bite of flaky pie made Wing a convert. Pie rating = 4.0, A+.

I SPY—A GRIZZLY

There's only one thing in this world I am truly afraid of: grizzly bear. On a family trip to the Canadian Rockies and Lake Louise in 1981, when we were somewhere in Montana, I (all of twelve years old) complained, "When are we gonna be there? I'm sick of this car. I'm bored! Are we there yet?" Dad had it and tossed back a book he'd just finished, *Night of the Grizzlies*. What was he thinking? I couldn't stop reading. In my memory I turned the last page as we drove up to the log cabin where we would stay the next week, mountains looming behind. Immediately I asked for my entire summer allowance in one lump sum and headed for the gift shop. On trail the next day I donned bear bells head to toe. Walking stick in hand, I sang, whistled, and jingled my way into the Rockies. My parents shook their heads in disbelief.

Keeping that story in mind, Wing and I took off for a late afternoon walk to a waterfall in Glacier National Park, a mile in from the campground parking lot. Near the trailhead I broke into a sweat and panicked. I ran to the campground store to buy a bear bell. The joke

is, "How do you tell the difference between black bear scat and grizzly bear scat? The latter is filled with bear bells and smells like cayenne." It didn't matter; I was comforted.

Tinc, tinc, tinc. We walked along the trail and in no time were at the falls. It was beautiful. We soaked our feet in the cool mountain water. We had passed other hikers who said there was a moose ahead but otherwise it was uneventful and quiet.

About a quarter mile from the parking lot on the way back, I was watching my feet step along the rocky trail when Wing suddenly said, *"Back up, back up, back up!"* Thirty or forty feet ahead in the middle of the trail was a big grizzly. She turned and looked at us. As we carefully backed around the bend, we lost sight of her. *"Shit. Shit, shit, shit! What do we do?"*

We backed up some more and waited. A family came up the trail behind us, mom, dad, and little girl. We told them about the bear ahead but the dad said, "Wow, we've been waiting to see one all day!" He took off around the bend with his daughter and his bear spray.

The bear was right there and this time reared up on her back legs. "Okay, back up, back up, back up!" The family was back where we were—what an idiot that guy was. We waited. The bear obviously had some business on the trail. All we could do was wait.

Five minutes passed. It seemed like hours. Another family, this one with several kids, came up the trail. We told them about the bear ahead. They didn't even break stride!

"Aeyyuuup Bear!" the man cried.

As his wife walked by she said, "He's a game warden in Alaska." So what, he's gonna flash his badge at the bear? The family passed, the other family followed, Wing and I scampered after them, not wanting to be left behind.

The bear was gone. We joke that we'd still be on the trail if the warden hadn't plowed through with all his burliness. Smart? Who knows, but we made it that last quarter mile without incident.

Without a doubt, it was time for a beer. Lake McDonald Lodge was a mile from the campground. We jumped into the car, still shaken, and took off for the huge 1920s Swiss-style building. After a couple long drinks from our frosty glasses, we looked at each other and knew there'd be no staying in that campground tonight. Wing took the credit card and booked a room. In a motivated burst of efficiency we packed up camp and were back at the lodge for a late dinner. The stars were popping in the night sky as we wrapped ourselves in a blanket and sat looking up from the porch. We'd seen a grizzly—up close and personal—but it really hadn't sunk in yet.

SANDPOINT BEACH

This morning we walked into downtown Sandpoint, Idaho, for breakfast. What I wanted more than anything was toast with peanut butter and jelly. This is no easy task on the road, where it's all skillet breakfast, steak and eggs, oatmeal—not a lot of toast with peanut butter. You begin to crave these homey things when you're traveling.

The sun warming the air, we took our lounge chairs and headed for the beach. This was my beach. The beach where I grew up, spending childhood summers with my grandparents, uncle, and cousins. The beach where Grandma would sit for hours while I ran through the sand, dove into the water, ran to get a push-up, ran back into the water. The beach where the boy drowned, where I'd hear the theme from *Jaws* every time I put my head underwater, where I had my first crush on a boy, where Grandma finally let me have my independence. Bless my Grandma's heart; she spent a lot of time at that beach.

Wing and I sat and read for a while, then the water beckoned. I wanted to dive off the dock, which seemed smaller than I remember. Some kids were playing on it so I swam out to the logs instead, a float on the lake. Wing stayed on the dock. Next thing I knew the kids were charging him, trying to launch him into the water. Wing had this look of disbelief, while they had one of determination. Well, all the kids went into the water and Wing managed to stay dry. The kids loved this challenge and made one more attempt. They failed. After all this excitement, we were ready to warm our toes in the sand.

CONNIE FRANCIS, MOVE OVER

We spotted a Chinese place in Sandpoint and decided to check out the Bamboo Restaurant. A tremendous amount of love and attention had been spent decorating the interior. This was no ordinary Chinese restaurant. Plants were everywhere—wrapped around posts, tacked up to and across the ceiling, everywhere. The

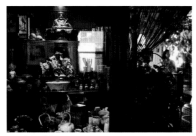

Bamboo Chinese Restaurant,
Sandpoint, Idaho

food was great. We spoke quietly, wondering whether we should approach the hostess for an interview. We went for it.

Her story was fantastic. Connie had been a nightclub singer in Hong Kong. She met her soon-to-be husband there and left a rather glamorous life for restaurant work in Sandpoint. She obviously missed it. When a song came on she said, "Listen, this is my voice." It was a Connie Francis song, sung by Connie of Sandpoint. The last time she and her husband went to Hong Kong she made the recording. Naturally, our next question was would she sing for us. She did, standing behind the cash register with the plants, the mirrors, the lights—and her voice filled the room.

BORDER PATROL

We thought we'd camp along the coast, but the pull of the big city was too much and we headed for the border. Enough of road life—big city, here we come.

The Canadian border crossing has never seemed like a *real* border crossing in my book. I mean, come on, it's Canada. When it was our turn to pull up to the guardhouse, we were all smiles and excitement. That soon ended.

"Where are you going?"

"Vancouver!" I was leaning over, both of us beaming at our young, militant border guard.

"For how long?"

"A month," Wing said.

"Actually, two weeks," I conceded.

"Well, what is it, a month or two weeks?" She was not happy.

"Two weeks."

"Where are you staying?"

"Actually, we're not sure." Dead stare. "See, we're traveling around the country . . ." Wing tried to tell her our story, then trailed off.

"Is there a problem?" I asked.

"Well, if I were going somewhere for two weeks I would know where I was staying!" I almost retorted that maybe that was just her personality—but thought better of it. Perhaps her braid was a little too tight. Wing tried again to explain what we were doing.

"How do you plan to pay for all this?" she threw back.

"Traveler's checks and credit cards."

Long pause, checking us out, checking out the car, reading our stickers on the cartop carrier. Why did I put the Y B NORML sticker there? Note to self: scrap *What Would Scooby Do?* and stick with state park stickers. Shit, she is not going to let us through.

Finally, almost in disgust, she waved us on. In light of what happened twelve days later, maybe she knew something we didn't. That will probably be the gentlest border crossing we will have to Canada for a long time.

HONEY, DON'T BACK OVER THE PROSTITUTE

In search of a hotel we headed for Chinatown in Vancouver. It didn't look good. Chinatowns notoriously neighbor some of the worst parts of a city. But Hotel Patricia was listed in our guidebook, the lone bargain hotel in the area. When we parked a few doors down, we tucked all our stuff under the seats.

We were surprised to see a car pull up ahead, a gentleman get out, nod to a woman standing near us, and walk into a small hotel. She followed. Wing noted, "Well, somebody just got some business." It became clear that people were getting all kinds of business in this little stretch of Hastings Street.

It was late. All other hotels around us were obviously pulling in another kind of clientele, so we decided to stay at the Patricia. Inside it was clean and quiet, and the room was basic. We headed for the night market in Chinatown. Gain Wa Restaurant was bustling and bright even at this late hour.

Bruce Lee kitsch, Chinatown, Vancouver,
British Columbia

We don't live in the best part of town back home. I know a lot goes on behind the scenes but we do have a sense of neighborhood. People know each other, help each other out, say hello. But going up to our hotel room and walking to the restaurant put me on edge. I didn't feel safe. I struggled with how much of what I felt was because of my white upper-middle-class experience and how much of it was a real reaction to danger.

Wing, of course, hardly noticed. He has lived just off Lake and 15th, a popular drug and prostitution corner in Minneapolis, and he has talked with many people from every walk of life. It's his work. "People are just people. If you talk and respond to them with that in mind, you don't get trouble."

True. I watched him handle men and women who crossed our path during the next two days. He's relatively open, calm. "Hey, no 22, thanks, man," to the drug dealers, a nod and a Canadian dollar in the hand of the down-and-out. "God bless you, sir."

Wing's dad always gave free coffee and a bowl of soup to those who came into his restaurant and couldn't afford a meal. Sometimes you just have to calm down.

And sometimes you have to decide to move. We found out from Wing's family that we were in the poorest, worst two blocks not only in Vancouver but all of Canada. Why did this not surprise me.

I felt a little more comfortable during the day—until Wing took out money from a bank cash machine. As he was trying to put it in his bag, he dropped three hundred dollars of twenties on the floor. A big, bulking guard rushed over and stood in front of us, arms akimbo, watching. Wing tucked it away. The guard said, "I wouldn't do that again, not in this neighborhood. Go on, be safe." All righty then.

Near the bus stop four drug deals were transpiring at once. There was barely room to pass. Breathe. Down the street another crowd was waiting in line. A restaurant or grocery owner was unloading crates of fruit, vegetables, and food while others were dividing it up. Someone was reciting the Bible. Addicts were strung out, not able to stand still, moms with kids, old men.

After another great meal of Chinese vegetables at Gain Wa, we tried to sleep, but it was Saturday night and our corner of the world seemed to be the hub of who's got it and who's gettin' it. "Hey, hey YOU! Hey, hey YOU!" It went on for hours.

"Where's the Vancouver in the brochures, honey?"

When morning arrived it was time to say good riddance to Hotel Patricia but not before Wing videotaped three prostitutes who ran our corner. It was sad and hard to watch as they struggled with the morning, strung out, stumbling, already looking for business.

SHRIMP BALLING

We woke up craving dim sum. Since it was Sunday, we headed south to Richmond, a suburb of Vancouver known as Little Hong Kong. The population is 40 percent Asian, mostly Hong Kong Chinese. When we saw signs in Chinese characters, not English, we knew we were there.

Wing and I have a tendency to overorder when we eat out. Dim sum provides the perfect opportunity to do so, and after this meal in Richmond we coined a phrase for it: shrimp balling. When Wing left the table to get a paper, I decided on two orders of shrimp balls instead of one. After all, we were hungry. I thought I loved shrimp balls, but once they came I realized it wasn't shrimp balls I loved but vegetable stuffed dumplings. Each order was four transparent sticky pink balls, not two, so we had eight shrimp balls total.

We enjoyed the first two. But the others sat, getting colder and stickier. I thought about the big spoon, a ritual on camping trips when the group must eat everything that was prepared so as not to pack it out. Big spoonful by big spoonful. You know, serving spoon size. Chocolate pudding pie brought down my Girl Scout troop when I was thirteen. The taste memory of pudding and graham cracker crumbs still brings on a gag reflex. We didn't have to pack out of Richmond, so we left those shrimp balls cold in their tin.

"Smells Chinese," Wing commented as we walked off the dim sum. Nose to the wind: "Smells like something Mom threw over the radiator." Not sure what that meant, I probed. Apparently his mom had all kinds of things in the house brewing, cooking, or hanging over the furnace. Chickens, herbs, dried fish, tea. This created a distinctive smell, not offensive. But if Wing opened a can of shoe polish, she noticed and would shoo him out. She hated shoe polish. It's amazing what the mind recalls with smells. And not knowing Wing's mom, I keenly appreciated his recollection.

SMOKED OUT

In our Vancouver guide we read that the largest Buddhist temple in North America was in Richmond. It was hard to miss. It took up an entire city block, and its lot was packed with cars. The first bottleneck was at the incense shop. Worshippers lit thick yellow sticks of incense by touching hot red coals in a large cast-iron vessel. Smoke was everywhere as each visitor held at least ten or more burning sticks—kids, too.

At the foot of Laughing Buddha there was a kneeling pillow and an incense box filled with sand. Three bows and a prayer later, each person poked incense into the sand and moved to the next altar. It reminded me of a Spanish Catholic church. Each Buddha, like each saint, is offered prayers for different reasons or in hopes of receiving various gifts or wishes. Men in suits, women in traditional outfits, women in hottie T-shirts, monks, and children with Hello Kitty backpacks—all moved through

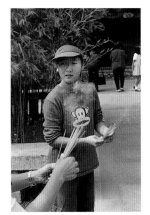

Buddhist temple, Richmond, British Columbia

this maze of altars and buildings praying and paying respect to deceased relatives. Along with incense, people brought food; rice, fruit, dumplings, and vegetables were set on tables inside the Great Hall.

Later we learned that Newman, the brother of Wing's sister-in-law, designed the Great Hall and one of the other buildings. The next week he gave Wing, Mom, and me a guided tour of the complex and obtained permission for Wing to photograph wherever he wished. What amazed me most were the workers. Wearing traditional clothing and woven pointy hats, they were using a hammer and chisel on the cement to create a narrow channel in the concrete. Yes, 2001, and the most accurate way to make the channel was by hammer and chisel. Wing and I finally were smoked out, literally; we couldn't handle the heavy incense in the air and headed back to the city.

SEPTEMBER 11

Today Mom goes home. Our most memorable day of her weeklong visit was yesterday. We were up early to catch the ferry to Victoria—ah, Victoria. I've heard so much about this city on Vancouver Island because Mom sent my grandparents there for their fortieth anniversary. My dad made a box for their gift; you pulled a little tab and a long ticker tape spooled out the destination of their surprise adventure.

As everyone knows, when you go to Victoria you must have high tea at the Empress Hotel. High tea is a rather formal affair, including tea with milk or lemon,

finger sandwiches, and tiny pastries. This was Wing's first time. My mom was beside herself with excitement. The tea cost fifty bucks each. Mom and I loved it, but this would be Wing's last high tea experience. The tiny sandwiches with only a whisper of ham spread did him in. We bought him a barbecued pork bun at a Chinese bakery a few blocks from the hotel.

After a long day of sightseeing, we gazed at the stars on the ferry back to the mainland. We tucked ourselves in at our separate hotels and made plans for an early meeting to drive Mom to her morning flight home.

Morning arrived a little too early but at least I got dibs on the first shower. As I was about to step in, Wing yelled, "Honey, shut off the water! Come here!" I looked around the corner and saw the unbelievable footage of a plane flying into the World Trade Center. *Shock*. What is going on? We flipped through the channels trying to grasp what was real. I called Mom.

She was staying at a small European-style hotel a couple of miles from us and was the only American there. She was okay. The owner met her coming down the stairs for breakfast, asked if this was her first time down, walked with her to the breakfast room, and stood by her chair while she watched the news.

Time stopped. Mom came to our hotel, and we all climbed on the bed and cried and watched and watched and watched the television. Finally, we had to turn it off for a while. We walked to the corner coffee shop where we had spent the past several mornings, and we tried to find comfort in this small place away from home.

WELCOME TO HAWAII

We hit the beach—really, the first thing to do when you reach an island paradise. We got our feet wet in the Waikiki surf, then turned around and promptly found ourselves at the beach bar ordering Mai Tais with a mahimahi sandwich. Thirty dollars plus tip. Welcome to Hawaii.

It was quite a scene on the beach—all kinds of bodies in all kinds of flowered beachwear propped in the sun. One person had built up the sand to lean at just the right degree for maximum tanning on a fluorescent floatie. Old-timers were in beach shelters closer to the road, playing cards or dice, intent on pursuing some form of gambling.

We saw a tourist industry desperate for tourists. Cocktail cruises were 50 percent off, there were closeout sales on Hawaiian shirts, and signs in store windows said "closed." I bought a loud Hawaiian-print dress covered with palm trees and sunsets simply because the woman selling it pleaded, "Come on, help me out." The terrorist attacks of 9/11 hit hard here. People talk less of national security and more about economic viability. The papers are filled with articles on the governor's trip to Japan to reassure that country's tourist population that Hawaii is safe. Japanese tourists spend $260 per day while visiting Hawaii; mainland tourists spend $150. Another article asked grocers to donate pet food to the Humane Society to halt the rush of pet owners turning in their animals because they could no longer feed them.

It's strange to be a tourist. You are an experience taker—even with the best of intentions, this can make you sad. Take only photos, leave only footprints. What is that supposed to mean, anyway? Once you return home, your photos end up in drawers. You can't even remember where you were when you took them and economically you've dissed your host if that's all you brought back. What motto do you live by?

Economic warriors. I don't mean to be flip. Being on the road for a year documenting the changing face of America is a luxury. Then you add on the state of our nation and the world—there are days when our project seems ludicrous. We've thought about coming home but find that we are compelled to continue, to still be out here spending money. We consciously choose where we shop, where we eat, where we go. You can donate money to a cause and you can spend money for a cause: to support the livelihood of small business and industry. Economic warriors. Is this what I really think? I don't know—I'm just trying to work it out.

ALOHA CHINATOWN

We loaded up on beach must-haves: two rollable grass woven mats, a fluorescent floatie with pump, one floral print towel, and SPF 30 sunscreen. Off we went to find a public access point to the beach and take our place among other thrifty "two blocks from the beach" high-rise rug rats. Wing broke a sweat pumping the green floatie to life and hit the water first. He lay stomach down, hands and feet dangling in the sea as he slowly worked his way out from shore. The lower half of the floatie popped out between his legs like a flag marking his movement through the surf. For a guy who doesn't like water much, he paddled, floated, and maybe even napped for a good forty-five minutes. He'd found his water buddy.

When we had all we could take of sun and sand, we showered and made our way to old Chinatown in Honolulu. Something was amiss. People walked slowly, there were no frenzied shopkeepers dickering with old women trying to get a bargain on lychee nuts, no elbowing or shouting or honking. It had been islandized or aloha-ed or something. We couldn't put our finger on it but this was unlike any other Chinatown we had seen. We ate fresh scallops and Chinese vegetables at the oldest Chinese restaurant in Hawaii while we watched the street and the languid activities below.

THONG-A-THONG, THONG

The next morning we rented a beach buggy to explore Oahu. At Diamond Head, millions of visitors each year hike the trail to the Honolulu overlook. It reminded me of the Grand Canyon's Bright Angel Trail, where women in jelly sandals and men on the verge of a heart attack huff and puff along. Eighty-some stairs

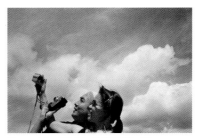

Diamond Head Crater, Waikiki, Hawaii

and two pitch-dark tunnels later, we were at the overlook. A man sat at a table giving away certificates of completion to those wanting their trek documented. Who gets these things? Plenty of people, because the guy was constantly busy—writing certificates, taking photos of people or being in photos with them and their smiling, sweaty, red faces. In contrast, a group of young local women had used the trail for their morning workout. They were all spandex and water bottles—this was no big deal.

Back at the parking lot a no shirt, no shoes kinda guy asked for a ride. Without thinking I said, "Sure." He was from Ecuador and had been here a couple of weeks. Wing was tense. I realized it wasn't a good idea in these times to pick up random hitchhikers. He was peculiar but harmless, and after dropping him off we looked for a good beach to wash off Diamond Head dust.

Our wish was granted at Kailua. We climbed through the lush plants and mist of the Koolau Range. On the other side was a long white sand beach that went on forever. We found a quiet spot, ran for the waves, stood in the breaking surf, and dove into oncoming walls of water. The bay was dotted with rock outcroppings in the distance where the water curved to meet the sky. This felt like Hawaii.

It was hard not to notice all the thongs. Thong-a-thong, thongs. Nobody in Minnesota would even think of wearing a thong in public unless it was *under* something else, and even then it might be questionable. In Hawaii there was flagrant thong wearing: walk along the beach in a thong, stand in knee-deep water in a thong, lie facedown on a towel in a thong. The worst part was that these women looked great. They belonged to a very exclusive club; I'd say that no more than .5 percent of the population could pull off this thong wearing successfully. I tried not to get depressed and stood proud in my sporty shorts and tank bathing suit that covered over half of my lily-white Minnesotaness.

WAILUKU COUNTY FAIR

Our first morning in Maui—eggs, papaya, coffee, browsing through the local paper—is the way all mornings should be. The headline read, "Wailuku County Fair Parade and Fun Starts Tonight." What luck. A parade. Is a Hawaiian parade different from any other county fair parade? We would soon know.

The crowds lined the main roadway by the school. It seemed the entire city was showing up. We bought three-dollar tickets for the fair, then staked out a spot on the curb for the parade. Wing took off to photograph while I held our place.

We are staying farther south on the island, where it hardly rains, so I was wearing a tank top and shorts. Clouds were rolling in and people were breaking out umbrellas and raincoats. I felt goose bumps. The parade wouldn't start for ten more minutes. I needed a sweatshirt but everything was either scary floral or Samoan sized. Finally, I found a T-shirt. We made it back to our spot as the first line of floats approached the corner.

In fact a Hawaiian parade is very much like any other county fair parade. Lots of Boy Scouts. Lots and lots of Cub Scouts, peewee baseball teams, fire departments, bands, Girl Scouts, girls in tutus, souped-up cars, announcers from local radio stations, beauty queens, and, of course, politicians. The parade went on for two hours. Everyone stayed until the last float passed, then all rushed into the fair to get in line for food.

The food choices were overwhelming. We were giddy with delight. Portuguese plate, Hawaiian plate, noodles, satays, sticky rice, sausage, sweets. Our motto had become "everything all the time," so we did it. The Hawaiian plate was our favorite; the Portuguese, second; fried bananas, third. Savory definitely rules over sweet.

When we had eaten ourselves silly, we stepped into the entertainment tent. The hula school was giving a demonstration. The young girls were in front, the older in back. Everyone wore the same outfit—grass skirt and coconuts. Yes, coconuts. And could they hula! The fast hip-shaking took me by surprise. I always thought of hula as slow, smooth movements with the hands telling a story, but not this hula. This was get-it-in-gear hula, the somebody-stop-me hula, the I've-got-a-story-for-*you* hula.

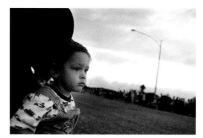

Wailuku, Hawaii

The next group was the Little League baseball team—U.S. champions! The Maui baseball team had just returned from the tournament on the mainland, which they had won. Their second time, too. As each boy's name was called, he stepped forward, tipped his hat, and something was said about his game. The crowd roared.

The Japanese drummers followed. Big drums were rolled in, and these tiny kids just started whaling on them. It was an amazing sound. You could feel it in your chest each time they struck with the mallet. It looked like hard work; the littlest ones were putting their whole bodies into it and were breaking a sweat. The entertainment continued, but we were full and sleepy and had a bit of a drive ahead. We said good night to the fair and the festivities and headed back to our cabin on the beach.

ALOHA IRONY

On our way to Lahaina we stopped for coffee at our little spot down the road. We had been here the past two mornings. Wing prefers to try new places all the time, but I was really liking this café so we kept coming back.

This morning I started talking to the man behind the counter while Wing went to find a paper. I couldn't believe it—he was raised in Minnesota. He had an accent that could have been from anywhere, one of those people who had lived all over and developed an indistinguishable twang, clip, and slang. His roots were in St. Paul; he did not miss the Winter Carnival and he remembered the butter head of the Dairy Princess and food on a stick at the Minnesota State Fair. He had found his permanent home now: "Maui, the best place on Earth."

Lahaina is rife with tourists and really bad art. It's incredibly noisy. But I wanted to see it all. We toured, poked, wandered, and stumbled on this pretty white house, the oldest around, now a museum. A Chinese Buddhist museum. Such a beautiful place. A woman greeted us at the door. Her name was Busada. When we told her about our project, she was very excited in a quiet way and eagerly began to show us around.

This building has survived only because of the work of a few Chinese families who still live here in Lahaina. They refurbished it and pay Busada to host, research photographs, translate papers and documents, whatever needs to be done. She had a voice that gives you goose bumps. In my third-grade reading class, Jocelyn Frieburg had that kind of voice. I loved it, soft but strong, and the tone or vibration, something, just gets under your skin.

Busada arranged an appointment for us to meet Caroline, a fifth-generation Chinese resident who ran a bakery in Lahaina. You could go there at 5:30 A.M. for fresh, hot bread. On Thursdays she baked a special bread that her family had made for generations. We would meet her tomorrow and *try* to wake up to taste that bread.

That night we had light pupus on our patio. As the sun was setting, we'd slice pineapple, guava, mango, or papaya, then sit on the cabin porch, open some wine or beer, and I would return to the bookmarked page of *Hawaii,* James Michener's epic story of this land. I would get so mad at the missionaries that I'd start yelling at the book the way people yell at their TVs.

The irony was just too much. The missionaries worked so hard to destroy the spiritual and cultural fabric of the Hawaiians. Two hundred years later, Christians from the mainland come in hordes to Hawaii to see hula, wear leis, and experience aloha. It almost hurts your head, let alone your heart.

Economic viability here is founded in aloha—and what is it? Live and let live. Dance. Smile. Eat well. Welcome. Laugh. Love. Hang loose. I still don't really understand all it encompasses, but I do understand that what happened was a tragedy.

NA PALI COAST

We love our little house on Kauai. This rented place is inland from the beach, in with all the chickens, geckos, cows, and horses. The main floor has a porch, living room, bathroom, and small kitchen; the upstairs, a loft with a bed, looks out over the garden. At 5:00 A.M. it seems like it's right over the chicken coop, but we love the chickens. We feed them every morning (but not until 8:00). We are nesting here; it feels good to have a home. We rent movies, buy groceries, make breakfast. The delis here are so different and we can't get enough of the poke (raw fish, onion, soy sauce), seaweed salad, and kimchee (three kinds, no less).

Today we are heading to the Na Pali coast. It's a beautiful drive. The last beach we passed was covered with tents and a hippie crowd. To hike in past Kalalau Falls takes

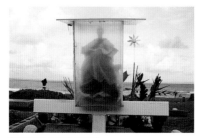
Cemetery, Kauai, Hawaii

some planning; most people go in for a week. Our plan is to make it to the beach and then, if we have the energy, continue to the falls. We started out, and as always on these major hiking trails there were people wearing jelly sandals. How do they get here? What part of their guidebook didn't they read? What part of the sign at the trailhead didn't they see? How about common sense?

The hike was amazing—the views, overlooks, the overgrown rain forest, streams, guava trees, birds, bugs, all of it a splendor. When we descended to the beach, we found quite a crowd. A sign lists all the people who died just this year from tides off the beach; that was enough to keep me far from the water. I'd read that the tides were so strong that people could drown just by wading knee deep.

We hiked across a stream to reach the beach. There were chickens and cats—unbelievable, way out here, chickens and cats. But that's how you know you're on Kauai. We ate lunch pulling our feet back while the waves crashed on shore—close but not too close. It felt so good to be out here. Even with all the people it seemed remote, secret.

After soaking up the sun we decided to head back. Within a half hour the rain was coming down like nothing I have ever experienced. We were soaked to the bone. I couldn't see out of my glasses. Everywhere the mud was slick as snot. We both fell a couple of times but didn't get hurt. It was exhilarating, refreshing, scary, funny, and one of the best things we did on our trip.

LAU LAUS

Driving out from our Na Pali hike we saw a family we had noticed on the way in still parked at the side of the road. We drove past. Wing was quiet. I knew what was coming. "Honey, we have to go back. I have to know what they are doing."

The blue pickup was tucked off the road with a round of chairs and a cooler. Smoke was pluming in the air, and the sounds of a chain saw were our first clue that this wasn't a picnic. Wing approached the woman leaning against the truck and told her our spiel. She was the grandmother, the matriarch of this family. The kids running around were her great-grandchildren. Her family was clearing her land.

I thought we were in the park reserve, and evidently we were pretty close. She had been unsure whether she owned the land or not, or if one of her older relatives had sold it, or if the government had taken it over, but just this year she learned it was hers. From what we could see the taro patches were intact; the stones still surrounded the beds, and taro was still growing. The children's father used

a chain saw to cut the largest trees while everyone else wielded machetes.

It was quite a sight. Several fires burned the brush. Everyone was busy. Wing went wild. He was so excited they agreed to let him photograph that I thought he would drop all his cameras in the mud. He did end up losing his flip-flops and the youngest child was sent to retrieve them. They called her the manager because she didn't like to work but liked telling everyone else what to do. The grandma kept me laughing. Her eyes were bright, her hair white and floating in the wind. I couldn't believe she was in her eighties. She was so proud of her family and what they were helping her do this Saturday. They work every Saturday until four and then, as a treat, go surfing. She doesn't surf anymore but she likes to watch. She grew up on this island. Her father was Hawaiian, her mother English. Her mother was a teacher with the missionaries and fell in love with her father, a farmer. She was one of eight children.

She told me about her own family of five children. She told me about the hurricanes that plague Kauai and claimed two of her children. She had seen so many changes in the Islands but felt the spirit of the place held things together. Her grandchildren and great-grandchildren obviously thought the world of her. There was so much laughter among them. Finally, Wing simply could not take any more photos—he'd run out of film. They were also done for the day and we parted ways, exchanging names and addresses. She invited us to stay with her if we ever come back to Kauai.

When we got into our car we heard a yell. The oldest grandson (in his late thirties) ran up to give us a packet of Grandma's lau laus. We were ecstatic—there couldn't have been a better gift. Lau laus are a staple of Hawaiian plate lunches: banana leaves wrapped around pork and taro leaves, tied with string and then steamed. We rented a movie, got some wine, and hunkered down in our jungle house— what a day.

THE PIILANI SISTERS

We'd heard about Duke's. It was an institution. Duke Kahanamoku was the young Hawaiian who brought surfing to the mainland. He was famous on the California coast, like a movie star. He swam in the Olympics and won a gold medal, according to the menu I was reading. The place was packed with the usual tourist crowd there for the all-you-can-eat salad bar. The food was good but the restaurant felt like a chain. In fact, we found out that although we were in the original location on Waikiki there were three others on the Islands or the mainland, with more in the works. Thought so.

While we were eating we heard lovely singing. Two women with ukuleles sang and played, strolling from table to table. They stopped just above us on the patio to sing "God Bless America." They were striking, their voices harmonizing beautifully. We needed to get this.

When we tried to see them later, they were nowhere to be found. Evidently they played only until nine. A missed opportunity. So we walked along the boardwalk in front of the restaurant and watched how other people vacationed on the Island. This place was swank, even had a private beach. Wonderful Asian sculpture was gently lit along the walkway. We followed torches back to our car and talked ourselves into returning. As a rule we don't go back. You miss it, you miss it. That's that. But just this once we thought we'd try to regain a lost opportunity.

The next night we showed up around 8:00, took a seat at the bar downstairs, ordered a pupu and a drink. I needed it, because I had worked myself into a tizzy. I don't consider myself much of a rule follower but at times I get hung up on appropriateness. Wandering into this dining room with a flash camera and video recorder was not falling into the appropriate category.

Wing kept saying, "What's the worst that can happen? They tell us to leave, so what." Ugh. I hate when I get in this mode. I took a deep breath and followed my oh so confident husband up the stairs into the dining room. The Piilani Sisters were working the back deck—perfect. We waltzed through the dining room and stood back by the bus station. Just a few moments longer and they'd be done with their song. Behind cover of the dining room divider, we told them who we were, how we heard them the night before, and asked if we could interview them just for a minute.

The hostess hadn't spotted us yet and the waitstaff just kept rushing by, too busy to care. We started the video and snapped off photos in a way that could pass as heat lightning. The women were cousins, from a large family group of singers. They'd had this gig ten years but had been singing together since they could remember. One cousin looked like she had Samoan blood; the other looked more Japanese. The character of her face reminded me of a Kabuki theater player—she smiled but the rest of her face seemed tragic. We asked them to sing "God Bless America" as we taped. We thanked them just as the hostess was clueing in to our business, and we skedaddled downstairs into the night.

What a rush. I felt like I'd been on some daring mission, averted danger, and was now swaggering down the alley drunk on adrenaline.

We couldn't wait and rewound the tape to view in the car. Their faces. That harmony. We got it.

MONK SEAL

Word was that southern Kauai had the best boogie boarding. Not bad snorkeling either. We couldn't believe the kids sailing by on boogie boards, past the lava rocks, engulfed in jade green foam that kicked them onto shore. It looked like a lot of fun but Wing and I are terribly chicken when it comes to ocean water sports. Give me a chlorinated pool where I can see lines on the bottom and I'll be in all day. A Minnesota lake, no problem. I have visions of muskies nibbling off my toes but it doesn't stop me. The ocean is a completely different animal. In fact, that's the problem: the critters. Seeing a shark on Maui was enough. The theme from *Jaws* emerged from the recesses of my subconscious to the overactive forefront of my imagination.

We rented snorkeling gear and joined the less adventurous waders in the calm bay on the other side of the rocks. The wind was kicking up waves and the water was a bit murky but it was fun to see all the fish. I kept trying to keep track of Wing but eventually gave up. Then I panicked (so unlike me)—but I continued to panic. I couldn't find him. I was choking on water from waves that overtook my breathing tube. I couldn't see. I was sure the sharks got him. Then he paddled up happy as a clam with all his fingers and toes. Oceans are unnerving.

I'd had enough snorkeling so we made our way to shore. We saw a group out on the lava rock staring into the waves. Sharks? We trotted over. No, something much milder. Turtles. Big green turtles that looked like they were playing in the waves, too. They'd launch out and catch a wave, and we could see them through the translucent green water swirling up and over as it crashed. Then they'd be back again. Now that's when I wished I weren't so chicken. To see those turtles underwater would be magnificent.

We sat on the grass to eat lunch, read a little more of *Hawaii,* and ended up snoozing. When we woke we noticed another crowd on the beach. Yellow caution tape was staked out around . . . something . . . a big blob indistinguishable from where we were. As we approached, I realized it was a seal. I gasped, "Is it dead?" It was lying so still and people were just staring at it. All of a sudden a twitch moved from its nose all the way to its back flipper. This seal rotated position with a big *frumph,* wiggled down into its spot, and once again lay still.

It was beautiful. I don't know if it was male or female, but it seemed like a boy. His coat was so gray and slick. It almost shimmered in the setting sun. I couldn't take my eyes off him. I kept waiting for him to move. I made Wing get his camera.

An old Russian who had lived on this island for fifteen years and swam here every day told me this was a monk seal. The seal had been there two days. They travel by themselves most of the time unless it's mating season. After a big feed off this shore, the seals often just haul up and nap for two to three days. Doesn't matter where—just binge and crash. A local volunteer group keeps an eye out for them and puts up the tape so visitors don't bother them too much. They are endangered and obviously vulnerable when power napping. It seemed so funny to me. Don't care, time to nap. The Russian bid me farewell with a little bow. We went back to our grassy spot to watch the sunset behind the snoozing monk.

MOLOKAI MO BETTAH

While staying on Molokai we checked out Kalaupapa National Park. On the north side of the island, it incorporates the town of Kalaupapa, where Hawaiians who had leprosy were sent during the 1800s and 1900s. The story is both tragic and inspiring. In the late 1970s, when drugs were discovered to alleviate Hansen's disease (as leprosy is now called), Kalaupapa was designated a historical site. Many residents still live there; life outside the small community seemed too overwhelming after living in isolation and

Unmarked Chinese cemetery, Big Island, Hawaii

suffering so much social ridicule, and they stayed even after they were allowed to leave. To visit Kalaupapa, you must be accompanied by a sponsor (a resident), and you must travel down about three hundred steps along the cliff edge, either on foot or by mule.

No one was around at the mule rental, so we continued on to the overlook along the cliff, a spectacular view. I couldn't help but wonder how strange it would be to live as a social, medical, spiritual outcast here amid such stunning natural beauty.

Our campsite at Papohaku Beach was on the far western edge of Molokai. The beach was a football field wide and three miles long, with white pristine sand. *No one* was on it! We took a walk and soon discovered why we were alone: the wind. The wind was so strong it blew fine white sand high enough to blast you clean from the knees down. It was intense, harsh, and oh so breathtaking. The wind stirred up big waves that crashed to shore. There were no other sounds.

Close to midnight we again walked along the beach. The wind dies down at night and the sand stays put. The sky was peppered with stars, and the stars went on to infinity. Waves were crashing into shore, lit by the glow of a waning moon. We felt like we were the only ones in the whole universe. I don't know how long we stood there but I really became lost in it all. At some point we wandered back toward the sound of our neighbor's campfire, crawled into our sleeping bags, and fell asleep. Molokai Mo Bettah.

A MAN AND HIS HOUSE

We woke and immediately called the Hearst Castle information line. We could get on the 10:00 tour and catch the noon movie. Perfect. To top it off, there was a coffee shop there, so I wouldn't have to endure *touron* status without caffeine.

We thought we might be among few people visiting a tourist trap on this day before Thanksgiving. Alas, the parking lot was practically full. We approached the glass-encased reservation operator with her headphone mike and recited our reservation number, which I had actually written down instead of faking it on the phone and was ever so glad I had. We had options. She could radio the bus and hold it if we wanted to catch the 9:20 and return early for the noon show, or we could see the 10:15 movie and catch the 11:00 bus and tour, or we could . . .

This was quite a production. I was overwhelmed. I thought calling and making a reservation would avoid any other decision-making tasks until after coffee. Sensing my

inability to process, Wing stepped in. "We'll stick to our original plan, thanks." A coffee and banana later we were ready for the show to begin.

We boarded the bus with 120 other people only after every bag had been searched. The bus wound its way up the hill while a recorded voice described the vast land owned by the Hearst Foundation and the grazing animals that used to be found here—zebras, gazelles, cows, wild horses, buffalo. When we reached the top, it was amazing. The castle looks more like a very small but wealthy village in Spain or Italy. We walked up a marble staircase to view one of the guesthouses and went on to see the grand hall and both pools. It was the most opulent visual experience I have had in a long time.

It was sensory overload. Everywhere you looked there were beautiful sculptures, tapestries, carvings, paintings. The unique aspect of Hearst Castle is that time periods and cultures are all mixed up: Roman columns, Persian tapestries, Spanish wood carvings, French paintings, English dinnerware, California furniture from the 1930s, reinforced concrete. The most impressive part of the tour was walking into the indoor pool area. The entire space, including the pool, was covered with one-inch-square glass tiles in cobalt blue, yellow, green, and, yes, 18-carat gold. Romanesque statues and a ten-foot diving platform graced the pool deck. Transparent marble lamps illuminated the interior. The effect was stunning.

The tour left us curious about the rest of the complex. Four tours are offered, each focusing on different parts of the castle. But

we resisted any temptation to spend the entire day here and headed down to catch the movie that *National Geographic* produced for an Omnimax theater. It depicted William Randolph Hearst as a visionary man, a great man. Maybe he just had a lot of money and a really big ego. Whatever the truth of the man, he did have an incredible house.

CHINA NOB HILL

We did absolutely nothing today. We woke up late in the bed of clouds, a king-size wonder bed with at least twenty pillows, turned on DIRECTV, and watched broadcast news until 11:00. Now if that isn't a precursor to a day of little consequence, I don't know what is.

A splash of water, a tooth-brushing, a hair bindy—we were ready to walk into the valley of dogs and babies. It was raining. We followed the suggestion of Jane (my childhood friend and our host in San Francisco) and had our morning coffee and paper at the new French bakery on the corner. I had the best almond croissant of all time, flaky, gooey, encrusted with almonds, accompanied by a giant bowl of coffee. Seemingly no amount of training in yoga or traditional Chinese medicine can break me of my love for morning coffee. Addiction, psychological or physical, isn't pretty.

The afternoon vanished with my only accomplishment being another trip down the hill to buy green beans, carrots, two cucumbers, and an umbrella. Wing attempted to play basketball at an ever elusive YMCA. He drove around for an hour and returned defeated: "San Francisco chewed me up and spit me out."

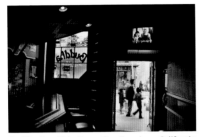

Buddha Bar, Chinatown, San Francisco, California

Before we knew it, it was time to head into the no-man's-land of Wells and John's apartment, a nameless neighborhood (shameful in San Francisco) between Nob Hill, Chinatown, and Russian Hill—Rush Nob Town, China Nob Hill, Chill Nob. Just brainstorming. I can't help throwing the Tenderloin into the mix—it's hard to beat the Tender Nob combination.

It was still raining. I don't know what it is, but when it rains in San Francisco it's really wet. We made a puddle in the entry as we greeted our hosts, Wells (a friend from Minnesota) and his partner John. Our umbrella didn't seem to hold up to the onslaught of drizzle encountered on our seven-block walk from the car. We set right in to prepare dinner—or at least haphazardly help John prepare dinner. Out of nowhere John made homemade Vietnamese egg rolls, sea bass with soy and wasabi sauce, potato and turnip gratin, and green beans. I'm always impressed by people who can host, be interviewed and photographed, and serve a meal without getting flustered. John's execution was exquisite.

Wing's interest in John was multifaceted. He is a second-generation Chinese American, grew up in San Francisco, went to Berkeley with immigrant Chinese, Taiwanese, and parachute kids (whose wealthy Hong Kong parents left them in the United States with nannies and expensive cars). John is young, works in corporate America for Gap, and is gay. It was fascinating to listen to John and Wells talk about their experiences and their views as a couple and as individuals on issues of race, identity, and relationship.

While Wing was photographing them, a city bus drove by. Their apartment is on a hill, above the corner bus stop, so passengers are eye level with those in the dining room—surprise guests at an intimate affair. John and Wells were accustomed to this but it left an impression on Wing. Every day since, he remains obsessed with capturing that image on film.

LOCKE

We found a Target store. I was so excited. I knew we could get everything we needed and everything we didn't with just a few quick trips down the aisles. Is that wrong? We bought a pair of twenty-nine-dollar suede pants for me, socks, plastic shampoo and conditioner bottles, engine oil, and a razor. And some Twizzlers, our current favorite road food. It was an oddly comforting experience.

Twizzlers in hand, we headed for Locke, California, thirty minutes south of Sacramento. The area was originally a pear orchard whose workers were Chinese immigrants. The early 1900s were rampant with anti-Chinese policy, including one law stating that Chinese couldn't own property. A group of workers approached the orchard owner, Mr. Locke, and asked to buy part of the orchard that they worked in order to build their homes there. He agreed, and an entire Chinatown developed. Now, Mexican pear workers live in those homes. Only twelve Chinese residents remain.

We drove down the small hill marked by a sign in English and Chinese: "Welcome to Locke." The narrow road led to Main Street, where we could see several cars and some pear pickers in a far-off field, but no people on the street. Everything was closed. A sole passerby greeted us. When we asked him about the shops, he said, "That's Monday in the Delta," and wandered into the only open restaurant, Al the Wop's. It was Sunday. Since Al's was the only business in town that was open, we followed him in.

The bar was huge; several locals, all white, were chatting with the bartender and eating steak sandwiches, the specialty of the house. I looked up to see the entire ceiling covered with precariously attached dollar bills. Is that gum holding them up there? We walked to the back, where tables were set with catsup, mustard, and peanut butter and jelly.

The fellow who greeted us in the street gave a nod. A newspaper article on Locke was framed by our table and featured his picture. We both looked over, he smiled, another nod. The story of Locke, the only rural Chinatown in the United States, had been made into a documentary and a book, *Bitter Melon*. Wing took notes on some of the old-timers who might still be around. Our friend told us about Mr. Lee, who was considered the unofficial mayor of Locke—he was the guy we needed to talk to.

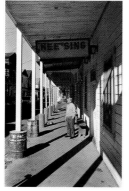

Ping Lee, Locke, California

From a pay phone in the neighboring town, Walnut Grove, we reached Mr. Ping Lee. He agreed to meet us at the grocery store he used to own in Locke. His son had recently sold the store to a Latino family who had worked there for many years. They were still learning the logistics and paperwork of the business, so Mr. Lee went in every day to help out. That's what he said, anyway. I think he just loved being in the thick of it.

While we were talking, a handyman from Samoa came to fix a leak in the roof. The good-natured bantering between Mr. Lee and him about the work, the billing, and the time it would take to fix everything made us chuckle. When they finished their repartee, Wing told Mr. Lee how much he reminded him of his father. Their similarities stimulated Wing's memories; during the next two days I heard a whole new set of Joe Huie stories.

Wing reflected on comparisons between Mr. Lee and Joe Huie. Both were self-made men who lived confidently according to their beliefs and convictions. They were happy, worked hard every day, and accepted what life brought to them. They were known for their kindness, were recognized figures in their community, and were generous, funny, and shrewd. Yet Wing thought there was another side to being that kind of man. He never really knew his father, he knew *of* him—a fact that didn't hit home until he interviewed and photographed his father at eighty-three for his first magazine job. Wing learned a lot from that interview. I was beginning to understand what a personal journey this cross-country trip was.

MOTEL 6

Wing and I had an unspoken understanding that we would stay in little mom-and-pop hotels during this trip. Now we have a stated commitment to Motel 6. Sometimes it's nice to know what you're getting for forty dollars.

After settling in at Sacramento's Motel 6, we drove into town. Tapas The World lured us in with cozy atmosphere, flamenco guitar, and its name. We dined on savory tapas, drank wine, and toasted Mr. Lee and the trip gods who guide us on our way.

When we walked to the car, a man was sitting in the bus shelter across the street with a radio to his ear. Bing Crosby was singing "White Christmas" and he was singing along with all his heart. I kept watching him. It was quite a scene—the night, the light from the bus shelter, his expression while he sang. The song ended as we got into our car. He opened his eyes and yelled, "I love that song," then saw me looking at him as we pulled away and yelled, "Fuck you . . ."

'Tis the season.

MR. PING LEE

We had agreed to meet Mr. Ping Lee again to learn more about Locke, and at 9:05 A.M. we called him. "You were supposed to call at 9:00!" Oops. We promised to meet him at the school, promptly at 11:00.

Wing photographed him sitting in the wooden desk where he sat in grade school. He told us his desk was strategically located next to the window where he could look out and talk with people as they passed by. We heard about school festivals, his experience growing up in this Chinese community, and how his grandchildren are now the only two Chinese students in the local school.

Mr. Lee had been worried about finding a wife, one who would be willing to follow very traditional Chinese values (namely, taking care of his aging parents). He found her in Sacramento. She was a schoolteacher, second-generation Chinese, and she moved to Locke and continued teaching in the Chinese school. They had two sons. The first son didn't want anything to do with being Chinese or learning the traditions. The second son couldn't get enough of his heritage and, even after going to college and traveling through the country, decided to move back to Locke and become a partner in the family grocery.

Mr. Lee said it was very hard on him to see his older son leave Locke and marry a Caucasian woman. It didn't surprise him, but it was difficult after he spent so much of his life preserving Chinese tradition and the Locke community. I wanted to ask if he believed culture and history could be preserved only through pure racial bloodlines. What was

it he felt compelled to preserve? What does he hope for his grandchildren in this global society? But I chickened out.

We walked down Main Street in Locke and he showed us all the important buildings on the strip, including the *most* important one—where he was born. He pointed out all the street benches where old men sit and watch the day go by: "If these benches could talk, you wouldn't need me!"

THE CARLSBAD MAFIA

Carlsbad, New Mexico, was a sweet surprise. I wanted to see the caverns. Leading cave tours at Blanchard Springs Caverns in Arkansas had been one of my college jobs, and I knew everything about bat guano and the furry critters who produce it. Carlsbad was legendary as the granddaddy of all caverns in the United States.

If you can believe it, we stopped at a tiny Chinese/Mexican restaurant, the China Lantern. This gem had just been sold to Jim, the Mexican contingent, but it had been owned by Ping for decades. Part of the deal was that Jim would be trained in the art of Ping's Chinese cooking and keep Chinese food on the menu. After all, people regularly traveled miles for his famous almond chicken.

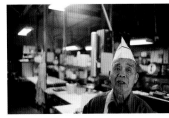

Ping, China Lantern, Carlsbad, New Mexico

We've never had anything like it either, so I took notes.

To Jim's surprise, Ping told me one of his secrets. After double battering the chicken, he sprays it with soy sauce, then blankets it with sliced almonds. This piece of chicken takes up the whole plate. There isn't a water chestnut or celery chunk in sight. That was the point. After years of clearing dishes from customers who left piles of vegetables on their plates, Ping decided to give them what they wanted: a big plate of chicken.

Ping, in his eighties, has a story to tell. At age eleven he came to the United States, but with some bitterness in his voice he wishes his mother would never have encouraged him to leave China to go to the Golden Mountain, as she referred to the United States. What he discovered here was a life of very hard work. The opportunity he found was countered with animosity and even hatred. It made him work harder to be more successful. But he repeats, shaking his head and his finger, "There is no Golden Mountain, not here or anywhere."

Ping married his high school sweetheart and moved to Carlsbad. He started a restaurant downtown but quickly outgrew that space. Anti-Chinese laws were still in effect and he couldn't buy land in town. He found a piece outside city limits and began to build. A week before opening an explosion destroyed the front half of the structure. Wing and I were horrified. "Was there a gas leak? A fire?"

"No," Ping leans in, "the Carlsbad Mafia."

Jim looks around and nods his head. "Yep, it was a bomb." It's hard to imagine a Carlsbad Mafia, especially after driving

through Carlsbad. But it runs downtown and enforces downtown business fees, and it didn't like Ping's success happening out of its jurisdiction. The Mafia hired the baker to drop the bomb on his morning run.

Again, we were stunned. Wing said, "Ping, weren't you angry?"

He just shrugged and said, "What could I do?" He had not yet purchased insurance. He had borrowed all he could from the bank. He was stuck. The best part of this story is that the community was outraged at what happened. The bank loaned him money. People came in droves to the opening of the China Lantern, and they have supported it ever since. Ping put four kids through college and a few years ago took his entire family, including five grandchildren, to China. Now, he's retired—well, sort of.

The lunch rush started and he had an order. Beef and broccoli. Ten years or more seemed to disappear from his face as he made his way through the kitchen to grab his apron, cap, and knife sharpener. Oh, yeah. Big knife, big sharpener. Did I mention he's virtually blind? But there he was, whipping this big knife up and over this sharpener as though he'd been doing it for forty years. Beef and broccoli flew into the air from the sizzling wok. Ping was in a groove. I kept hoping an order for almond chicken would come in so I could catch a glimpse of the legendary dish in the making.

JACUMBA

"Now we're cookin' with gas," exclaimed the tire company employee in Savannah who

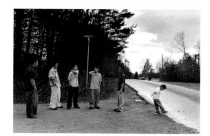

Hmong Lo Street, Hickory, North Carolina

helped us replace our dented rim and Michelin XSE after we clipped a street drain in historic downtown.

We're in the Deep South and it's spring. It's been a while since I've completed a sentence in my journal but I have made a lot of lists. The experiences along the road keep racking up, and I'm taking time to digest them—yes, that's it—I need time and perspective before committing my thoughts to paper or disk or memory or hard drive or whatever it is I'm working with on this computer. My *orange* computer. That's what I told the service desk the other day when I was having trouble with the battery charging: I have the *orange* one.

We're in Charleston, South Carolina, and it's beautiful. We spent January and February driving across the South close to the border and definitely sensed the increased security; Border Patrol was hidden behind every chaparral bush.

We also visited the numerous natural hot springs along the way. In one out-of-the-way spot, Jacumba Hot Springs in California, the pool had a real UN contingency—Germany, Korea, Mexico, Japan, the Philippines, Russia, Italy, and China were all represented. I guess it wasn't that out of the way. The Koreans

were exercising in the sauna, the German was making sure everybody showered before getting into the pool, and the Russians and the Italian were toting cocktails. World peace didn't seem to be on the agenda.

PLEASE DON'T LEAVE ME

New Orleans is all about food and we're all about eating. It was a good fit. We'd spent the past few days immersed in Mardi Gras, watching parades, eating crawfish, catching beads, and sucking down oysters. At one point we found ourselves trapped on Bourbon Street sandwiched among drunk college boys with cameras, half-naked college coeds, and born-again Christians damning us all to hell. Moments later the crushing force of the crowd choked us. We panicked. We couldn't move. We'd had enough of Bourbon Street.

Mardi Gras parade, New Orleans, Louisiana

A church flyer for a Vietnamese New Year celebration in Marrero, about twenty miles from New Orleans, caught our attention. We gastronomically readied ourselves for the switch from bread pudding to bamboo juice. It turned out to be a photographic feast— Vietnamese soldiers folding an American

flag, fan dancers, fireworks. There was even a Vietnamese town a few miles away.

The town was only a few blocks long with several large restaurants, grocery stores, and an outdoor market. At the back of the market, Wing spotted a dingy, double-wide trailer that seemed to house a Vietnamese coffee shop, his kind of place. It was filled with Vietnamese men smoking and playing cards. The only woman was the waitress. All eyes on us, we sat and ordered Vietnamese coffee. Wing wanted to photograph this scene but had left his camera and Lake Street book in the car. "I'll be right back."

"Please don't leave me here." I started to sweat.

"Honey, it'll just take a second." He was gone.

I felt abandoned in a foreign land. As soon as Wing was out the door, men at the next table leaned over to talk. By the time he returned, I was chatting with everyone, and all were ready to be photographed. Sometimes you just have to take a deep breath and relax.

FRANK H. WU is dean of Wayne State University Law School and author of *Yellow: Race in America beyond Black and White.*

ANITA GONZALEZ teaches liberal studies at the University of Minnesota. She cocurated the exhibit *Nine Months in America: An Ethnocentric Tour by Wing Young Huie* at the Minnesota Museum of American Art.

TARA SIMPSON HUIE is a Shiatsu massage therapist, Chi Nei Tsang practitioner, and yoga instructor.